IMAGES
of America

SOAP LAKE

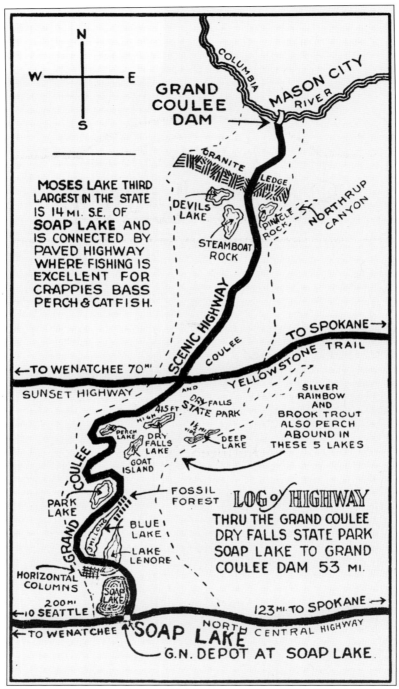

This early-1930s recreation map shows old highway names, prime fishing locations, and major attractions in the Grand Coulee of eastern Washington. (Courtesy of the author.)

ON THE COVER: Taken in the 1940s, this photograph is of the opening of bathing season on the shores of Soap Lake. (Courtesy of the author.)

IMAGES
of America

SOAP LAKE

Kathleen Kiefer

ARCADIA
PUBLISHING

Published by Arcadia Publishing
Charleston, South Carolina

Printed in the United States of America

Library of Congress Control Number: 2013935153

For all general information, please contact Arcadia Publishing:
Telephone 843-853-2070
Fax 843-853-0044
E-mail sales@arcadiapublishing.com
For customer service and orders:
Toll-Free 1-888-313-2665

Visit us on the Internet at www.arcadiapublishing.com

To Roxie Thorson for persevering over the years—she hung onto the Soap Lake Products business after her husband died when she was 27 years old. She watched the parade of history from the mid-1900s into the early 1980s, never wavering in her belief in the healing qualities of Soap Lake water. Over the years, she stood up to the Food and Drug Administration, which on more than one occasion threatened to stop her from selling Soap Lake Products because of the "unconventional" way they were manufactured. She prevailed, and so has the beautiful rock building she nurtured for six decades. It stands today, more beautiful than ever, the last vestige of a town with a remarkable past.

CONTENTS

ACKNOWLEDGMENTS

Many thanks go to Roxie Thorson, Marina Romary, Duane Nycz, Denise Keegan, Soap Lake Heritage, Linda Bonneville, Jane and Paul Klasen, George Waltho, Richard Bonthius, Joyce Pinkerton, Virginia Grove, Gordon Tift, Julian Agranoff, Woody Whitmore, Betty Coberly, the Webbers and their kin, Elaine Mullinex, the *Grant County Journal*, and Brenda Teals, a teacher of history who reminded me, again and again, why it is I love stories of the past. All photographs and print images are courtesy of the author unless noted otherwise.

INTRODUCTION

There are few places in this country that cannot acknowledge the fact that indigenous people saw the landscape and received the bountiful gifts offered by Mother Nature first. It is peculiar even now to consider how odd the name Soap Lake would seem to those who first discovered the aquamarine pond with briny water and a sulfurous clay lining. But this story goes back further than the first inhabitants.

Seventeen million years ago, most of the Pacific Northwest was a seething mass of molten lava. By the time of the first ice age in this part of the country, about a million years ago, the entire Columbia Basin, located in the heart of eastern Washington, was covered with up to 6,000 feet of basalt. For another 10,000 years, a series of floods thundered southward from melting glaciers, ferociously carving the Channeled Scablands of eastern Washington, leaving behind the most dramatic flood-carved landscape on the planet.

At the southernmost end of the Lower Grand Coulee, against the backdrop of ancient basalt cliffs sits an aquamarine lake unlike any in the world. Once a plunge pool for a giant waterfall that receded north as the floods abated, Soap Lake is known for the beauty of its breathtaking location but is most of all known for the remarkable medicinal qualities of the mineral water.

By the early 1900s, settlers heard about the lake from indigenous people who travelled through the area on seasonal food gathering, recreation, and trade routes. By 1904, the first general store appeared near the lake, and by 1905, the first sanitarium was open.

Sanitariums existed throughout the country as places people went when they were sick. Spas where treatment with mineral water was used had long been the custom in Europe. Spas in Saratoga, New York; White Sulfur Springs, West Virginia; Hot Springs, Arkansas; and Warm Springs, Georgia, flourished in the 1800s. The term "taking a cure" at a spa or mineral spring traced back to an early belief in the medicinal qualities of mineral springs.

Throughout the first decade of the 20th century, Soap Lake experienced tremendous popularity, made possible in part by Great Northern Railroad immigration agent Fred Graham, who first came to Soap Lake in 1906. At that time, visitors got off the train in nearby Ephrata and were picked up by wagon stage. After visiting Soap Lake, Graham noted that "I was impressed with the merits of the water from a curative standpoint, and that conviction has grown with the passing years." By late 1910, the Great Northern built a small station at Soap Lake.

Even before the first large hotels were built in Soap Lake, entrepreneurs were using steam-driven heat plants for evaporating Soap Lake water to produce salts and other products. The trade in Soap Lake Products was huge business for men like Tony Richardson and E. Paul Janes and his many partners who conducted a lucrative wholesale trade from warehouses in Seattle. Soap Lake Products were shipped by train and sold throughout the country. Roxie Thorson outlasted all predecessors by selling her Soap Lake Products through mail order until 1984.

The effectiveness of Soap Lake water in treating a serious health problem became nationally known in the 1920s through the efforts of the Veterans of Foreign Wars and the American Legion. Returning World War I veterans with Buerger's disease discovered that bathing in the water and using the mud arrested the onslaught of the disease. Buerger's is a circulatory disorder that results in restriction of blood flow to the extremities, causing flesh to decay, exposing nerves, and causing excruciating pain. The only treatment is amputation of limbs. Through the lobbying efforts of veterans, the federal government allocated $10,000 to fund a study on the effects of the lake water on the disease. With favorable results, the veterans groups went on to successfully lobby the State of Washington to build a hospital in Soap Lake for the treatment of the disease.

Throughout the late 1970s and into the 1980s, the Food and Drug Administration made efforts to stop Roxie Thorson from manufacturing and distributing Soap Lake Products. By then, the aging matriarch of Soap Lake's oldest hotel and Soap Lake's only surviving salt manufacturing business was able to stand her ground, making some modifications in her manufacturing process. She was advised she could make no claim for the products, despite filing cabinet drawers full of testimonials sent in by people who either visited the lake or ordered her products.

Precise dates are missing from many of the photographs, and there are countless stories lost or untold. Newspaper tidbits and blurbs, such as they were, from the second decade of the 20th century paint delightful written repartee indicative of the sense of humor and friendly nature of the small-town atmosphere that made Soap Lake the perfect place to grow up and a wonderful place to live.

The widespread use of penicillin after World War II and the progress of modern medicine changed the value once placed on mineral spas. The word "sanitarium" has fallen out of use or become incorrectly associated with facilities treating mental illness. People still declare the value of Soap Lake water for skin disorders and arthritis. The lake is, after all, highly alkaline in nature, and that really is what it is about—nature. Soap Lake rests sweetly in a beautiful, somewhat sleepy place, nestled against a backdrop of towering basalt cliffs that once served as side panels for an ancient waterfall that left behind a most unusual gift for future generations.

One

EARLY ARRIVALS

SMOKIAM (Soap Lake)

Smokiam is the Indian name for Soap Lake which in the Indian language means "Healing Salts."

We gather the above and following information regarding Smokiam Lake from two Nes Pelem Indians from the Colville Indian Reservation, whose pictures we present in this pamphlet.

Smokiam Lake was named by "Old Chief Moses" long before the white man knew of the existence of such a lake. The white man gave it the name of Soap Lake from its peculiar cleansing quality.

Soap Lake water is a great cleanser for the human family and no one knows this better than the native Indian whose people have visited Smokiam Lake every year for MANY years, bringing their sick and afflicted to drink of and bathe in its healing waters and they, the Indians, report some marvelous cures among their people.

On the shores of Soap Lake is now located quite a prosperous village known as Soap Lake, with three large sanitariums and numerous boarding and bath houses which are visited annually by thousands of people from California to Maine and from the Gulf of Mexico to the National Boundary. Canada, England and Alaska are also well represented here.

We bring it to you. You can now take the Soap Lake treatment in the privacy of your own home, and thus save the added expense of a trip to Soap Lake.

The story begins with the first people to discover the lake. Long before tribes, treaties, and reservation boundaries, indigenous people roamed the scablands, coulees, and shrub-steppe landscape of the Lower Grand Coulee. With a plentiful supply of wild roots nearby cultivated by the native people each spring, Soap Lake was an ideal spot to gather at the end of a long winter. Stories have been passed down about Soap Lake being a place where native people gathered each year to trade, race horses, and use the lake as medicine for healing horses and people.

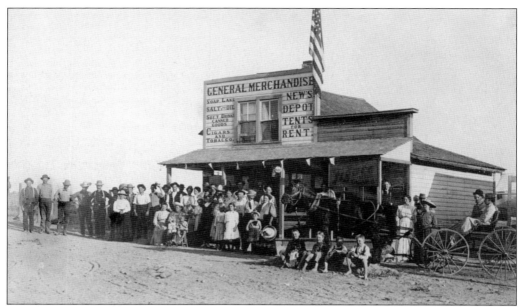

In 1904, Carl Jenson opened a small store where he sold Soap Lake products and rented tents. Civilization in Soap Lake at the time appeared to be an old corral that was filled with sheep each spring. The old-time sheepherders found that the lake was a good place to dip the sheep to cure scabs and kill ticks. There was also a small salt products factory nearby that burned sagebrush for boilers used to evaporate Soap Lake water. (Both, courtesy of Duane Nycz.)

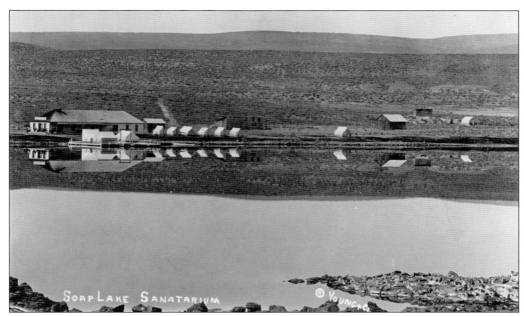

The Lombardy Hotel opened in the summer of 1905. It was built by Dave Gallagher and located on the west side of the lake. Tents were erected nearby for the overflow of guests. The Lombardy became a community center as well as a sanitarium where people came for treatment with Soap Lake water. It was the site of Soap Lake's first post office and first school. (Courtesy of Klasen family archives.)

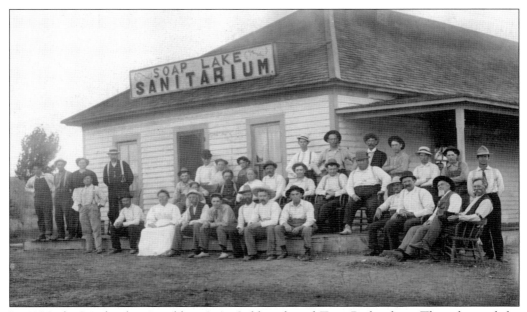

In 1906, the Lombardy was sold to A.A. Goldsmith and Tony Richardson. They changed the name to the Soap Lake Sanitarium. Most visitors arrived as patients. There was a full-time doctor to advise treatment. (Courtesy of Duane Nycz.)

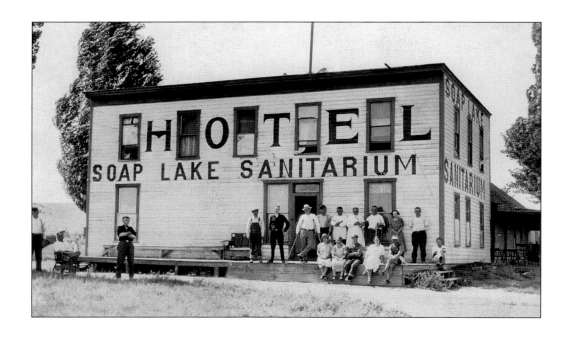

It was not long before the Soap Lake Sanitarium expanded, adding a new building to the front of the original Lombardy. Professional staff included a medical doctor, assistants, and bath attendants. Rates were $10 and $12 a week, including room, board, and baths. (Both, courtesy of Duane Nycz.)

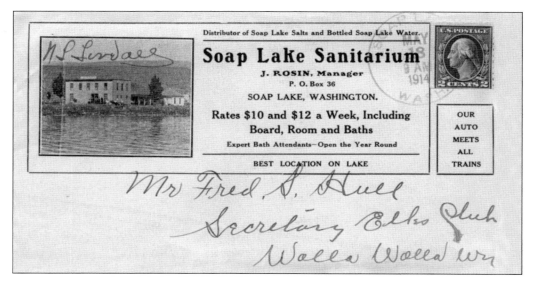

Distributor of Soap Lake Salts and Bottled Soap Lake Water.

Soap Lake Sanitarium

J. ROSIN, Manager
P. O. Box 36
SOAP LAKE, WASHINGTON.

Rates $10 and $12 a Week, Including
Board, Room and Baths

Expert Bath Attendants—Open the Year Round

BEST LOCATION ON LAKE

OUR
AUTO
MEETS
ALL
TRAINS

Mr Fred. S. Hull
Secretary Elks Club
Walla Walla wn

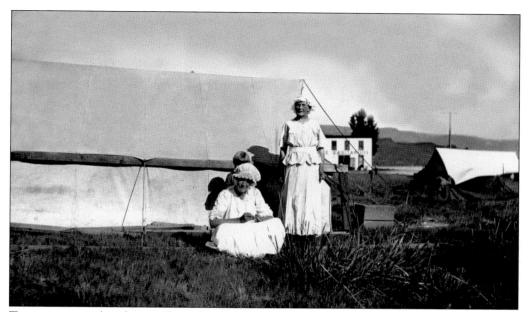

Tents were rented to the overflow of visitors. It was not uncommon to find a dozen tents perched along the shore of the lake on a summer day. (Courtesy of Duane Nycz.)

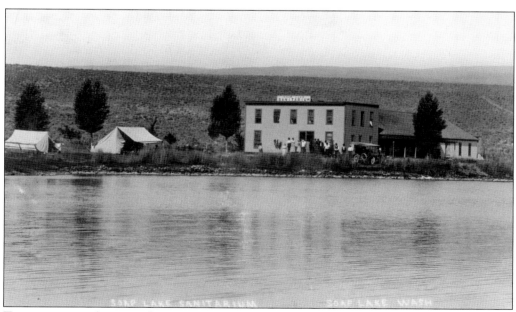

Tents were rented at several stores in town. Virtually every business establishment and hotel in Soap Lake kept a supply of tents. (Courtesy of Soap Lake Heritage.)

SOAP LAKE

THE MECCA OF THE AFFLICTED

THIS MARVELOUS BODY OF WATER IS FAMOUS FOR ITS CURATIVE PROPERTIES

NATURE'S CURE FOR RHEUMATISM, ALL BLOOD DISORDERS, ALSO, ECZEMA, AND IN MOST CASES A POSITIVE AND PERMANENT CURE FOR STOMACH, LIVER AND KIDNEY TROUBLES

Thousands of one-time invalids are now singing praises for the benefits and cures they derived as a result of drinking and bathing in the healing waters of Soap Lake.

HOTELS AND SANITARIUMS OPEN THE YEAR ROUND

FOR FURTHER INFORMATION ADDRESS

SOAP LAKE IMPROVEMENT CLUB

SOAP LAKE, WASHINGTON

The Soap Lake Improvement Club was the first chamber of commerce in town. It promoted the town by printing handbills and flyers and encouraged business owners to collect testimonials from visitors about how the lake helped heal their infirmities. (Courtesy of Marina Romary.)

Two

Soap Lake
Salt Products

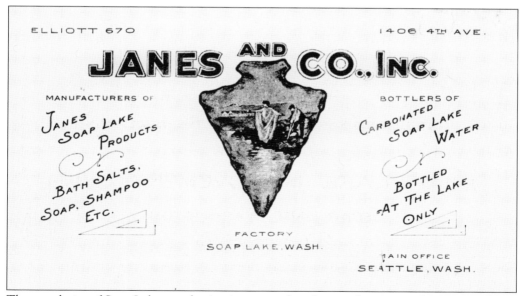

The popularity of Soap Lake as a destination spurred a salt manufacturing industry capitalizing on the desire of visitors to take products home to family and friends. The precise history of names and products has been difficult to document, but it appears there was a salt products business operating as early as 1901.

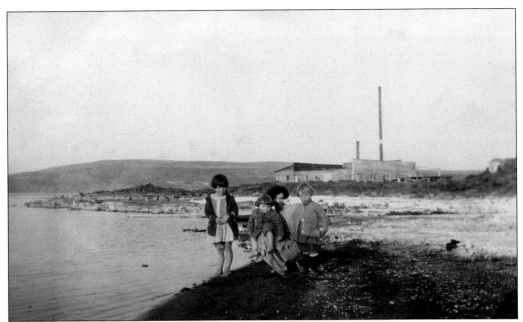

A young woman and three children pose on the west beach near one of the first salt manufacturing facilities. The first known plant was called the Soap Lake Remedy Company. Sagebrush was burned as fuel to heat boilers used to evaporate salts from the water. (Courtesy of Betty Coberly.)

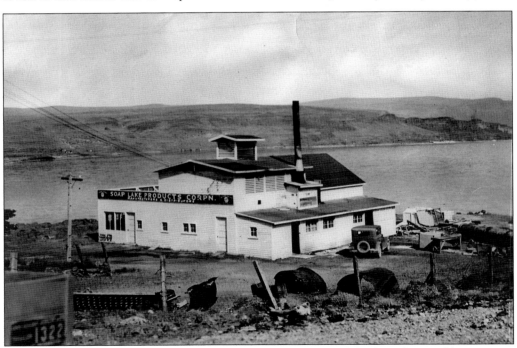

The Soap Lake Products Corporation expanded the operation of the first plant and began using coal. The plant was located on a site near the current residence of Bob Nacke. Products sold included salts, concentrated water, shampoo, nasal spray, and foot balm. (Courtesy of Bob Nacke.)

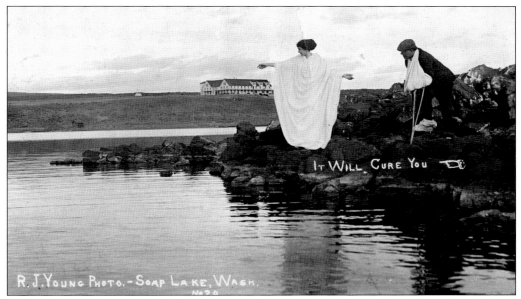

E. Paul Janes hired local photographer R.J. Young to stage this photograph along the shores of Soap Lake. Janes used the image on almost all labels and advertising of his Soap Lake product line. (Courtesy of Linda Bonneville.)

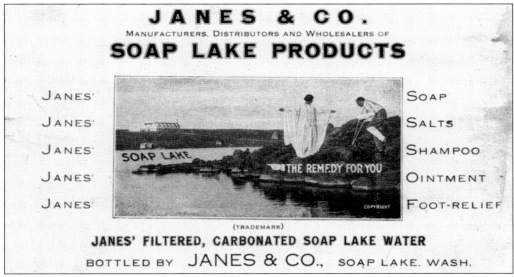

The above image is from one of E. Paul Janes's business cards showing the range of Soap Lake products manufactured by his wholesale distribution company. The spot where the photograph was taken was relocated in 2007 and published on page 139 of Paul Dorpat and Jean Sherrard's book *Washington, Then and Now*.

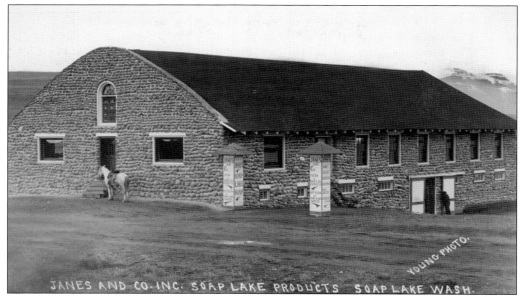

In 1910, E. Paul Janes constructed a rock fortress from rounded river cobble. This became the staging area for Janes's Soap Lake Products. Janes was a consummate promoter and real estate salesman. With a warehouse and sales crew in Seattle, he operated an elaborate network for the sale of Soap Lake Products around the country. This building is now the modern and cozy Inn at Soap Lake, located on Main Street. (Courtesy of Duane Nycz.)

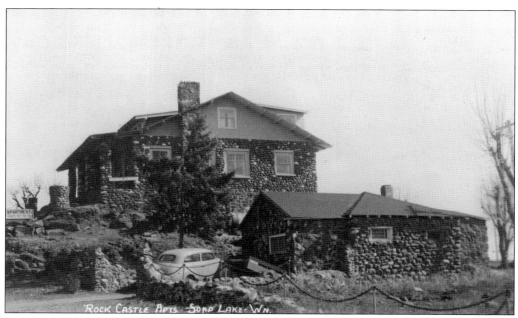

Between 1910 and 1914, E. Paul Janes built several rounded-rock buildings in Soap Lake. The one in the above photograph became known as the rock castle. It remains standing today along with several other stone cottages on the east side of town, one of which Janes used for his office.

"RESULTS TELL"

Thousands of one-time cripples and invalids, having regained their health and strength as a result of drinking and bathing in Soap Lake Water, now sing the praises of the unrivalled remedial properties of this natural medical sea. Hundreds of testimonials have been taken from the cured of almost every kind of disease by different individuals and interests at this lake. But it is not the purpose of this little booklet to present these here and make this appear like a patent medicine circular, we simply ask you to inquire from anyone you know who has taken the Soap Lake Treatment,—WE KNOW WHAT THE ANSWER WILL BE.

WHAT DOES THE WATER CONTAIN?

Perhaps there is no stronger natural mineral water known than Soap Lake Water. According to the State Chemist at Pullman, Washington, there are fourteen different chemical compounds in solution in this water. To present this analysis to the ordinary layman would serve no useful purpose, as the same would not be understood. Suffice it to say, however, that the waters are radio-active and such blood builders and purifiers as iron, sulphur, potash and magnesia are among the constituents. It is "NATURE'S OWN MYSTERIOUS BREW."

THE EXTRACT OF THE WATER

Can the mineral salts held in solution in the famous Soap Lake Water be extracted? By evaporating the Soap Lake Water the pure water goes away as steam and the remedial and curative properties are retained in the solids or salts formed in the vessel by evaporation. It is the business of Janes & Co. to obtain and market these salts.

JANES & CO.

Janes & Co. of Soap Lake market a valuable line of household remedies and toilet articles made from the famous Soap Lake Salts.

They guarantee all their products and on every package of Janes' Soap Lake Salts you will see the following plainly printed: "This package contains nothing but the salts obtained by the direct evaporation of the mineral waters of the famous Soap Lake."

All of Janes' Products contain in a modified form all the remedial and curative properties of the famous Soap Lake Water.

SOAP LAKE TREATMENT AT HOME

To bring Soap Lake to you so that you can take the Soap Lake Treatment in your own home, without the traveling, inconvenience and additional expense of the trip has been the worthy purpose of Janes & Co. and is the secret of their wonderful success. After years of experimentation, lots of hard work and a considerable expenditure of money, we now offer you "THE GENUINE SOAP LAKE TREATMENT" in the privacy of your own home. We are proud of our name and take pleasure in calling your attention to the quality of our products.

DRINK THE PURE SOAP LAKE WATER and take a genuine Soap Lake Bath at home. Full directions are printed on each article.

Our Soap Lake Treatment consists of the following products:

JANES' SOAP LAKE SALTS for the Soap Lake Bath dissolved in the ordinary bath water.

For toilet and bath, use JANES' SOAP LAKE SOAP.

For falling hair, dandruff and all diseases of the scalp use JANES' SOAP LAKE SHAMPOO.

Fir tired, aching and swollen feet use JANES' FOOT RELIEF.

For blood and skin diseases, rheumatism, kidney, stomach, catarrh and liver trouble use JANES' SOAP LAKE SALTS.

SPECIAL

JANES' FILTERED CARBONATED SOAP LAKE WATER. Guaranteed to contain nothing but pure Soap Lake Water, filtered and carbonated. Janes' Soap Lake products are the best, and are sold by all leading druggists.

Be sure to ask for JANES' Soap Lake Products and be sure that you get them.

JANES & COMPANY

MANUFACTURERS, DISTRIBUTORS AND WHOLESALERS OF

SOAP LAKE PRODUCTS

BOTTLERS OF SOAP LAKE WATER SOAP LAKE, WASHINGTON

Labels and descriptions provided robust details about the line of Soap Lake Products sold by Janes and Company. The quality of printing on product labels and the elaborate product descriptions for Janes's Soap Lake Products were highly professional.

The interstate commerce of Soap Lake Products meant a fortune for the manufacturing companies who shipped them across the country by rail. Janes mobilized a small sales force from his Seattle office where products were sold on a daily basis to pharmacies and druggists around the country.

The products were shipped by rail to a warehouse in Seattle and then to all points east. (Courtesy of Marina Romary.)

JANES' SOAP LAKE NASAL SPRAY

A complete atomizer charged with ingredients taken from the waters of the Famous Soap Lake and Magnesia and Menthol.

NOTICE--The following analysis is of the pure Soap Lake Water:

STATE COLLEGE OF WASHINGTON
CHEMICAL LABORATORY PULLMAN, WASHINGTON

REPORT OF WATER ANALYSIS

Serial Number, 1437. Dated March 14, 1914.
From Soap Lake, Washington. Date of Collection, February 1, 1914.

SANITARY CHEMICAL ANALYSIS		MINERAL ANALYSIS	
Results expressed in parts per 100		Results expressed in per cent of total solids	
Suspended matter		Silica SiO2	0.10
Odor		Sulphate SO4	17.69
Chlorides Cl	13.17	Phosphate PO4 (trace)	
Oxygen consumed		Carbonate CO3	28.92
Dissolved oxygen		Mg	0.007
Total hardness		Calcium Ca	0.014
Total solids	2.525	Sodium Na	39.58
Loss on ignition	9.040	Potassium K	1.24

REMARKS			
Silica (SiO2)	0.10	Sodium Carbonate (Na2 CO3)	51.08
Phosphate (PO4)	(trace)		
Potassium Cloirid (KCl)		Magnesium Sulphate (MgSO4)	0.03
Sodium Chloird (NaCl)	19.83		
Sodium Sulphate (Na2 SO4)		Calcium Carbonate (CaCO3)	0.04
	26.17		

ELTON FULMER, Head of Department of Chemistry.
CLARENCE ESTES, Analyst.

DIRECTIONS

Take the blower in hand, inhale gently up into each nostril every four hours during the day. At night, before retiring use the penetrative salve freely to oil up the inside of the nostril. Where the inflammation is so great that the air passages in the nose are closed, the first inhalation should be followed in 10 minutes by a second inhalation a little stronger than the first, and you will feel the fine powder penetrating the air passages, and every cavity in the head and every little passage-way and cell connected anywhere with the air passage of the head, the middle ear, and bronchial tube.

SAFE TO USE UNDER ALL CONDITIONS

Manufactured by

JANES & CO., Inc.

Soap Lake Products

Soap Lake, Wash.

Price $1.00

E. Paul Janes provided customers with a report of water analysis made at the State College of Washington in Pullman (Washington State University) from samples collected in 1914.

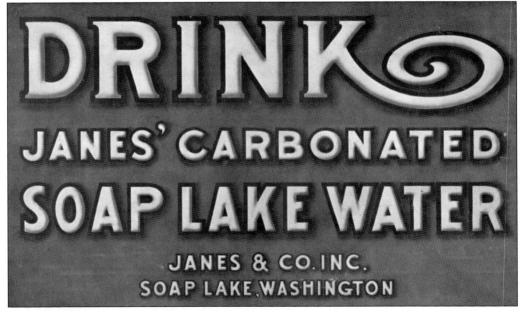

On April 26, 1915, the *Grant County Journal* reported the following: "Mr. George A. Fraser, MP of British Columbia left here for his home in Victoria last week. Mr. Fraser is a great enthusiast of Soap Lake and purchased a large order of products before he left. He had a special case packaged of carbonated water that he intends to present to his friend, Sir Richard McBride, the Premiere of British Columbia."

Three

A Growing Spa Town

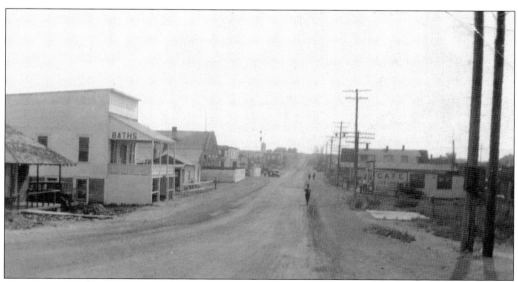

By 1910, Soap Lake was a booming one-dirt-road town. Hotels, bathhouses, cottages, apartments, and eateries were springing up in response to the growing population and popularity of the lake. The word was out about the effectiveness of the lake as a place to go for treatment of health problems. (Courtesy of Duane Nycz.)

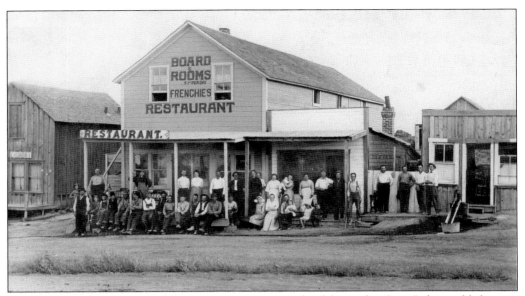

Frenchies Boarding House and Restaurant was an example of the perfect Soap Lake establishment. The town was still without electricity, and every business had an outhouse. The streets, businesses, and lodging facilities were lit at night by kerosene lamps. (Courtesy of Soap Lake Heritage.)

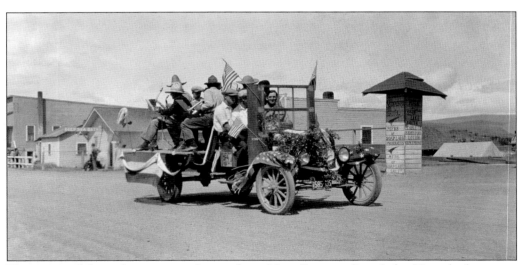

This is one of the earliest images of a parade on Main Street in Soap Lake. Note the large tent in the middle right of the photograph. The flatbed truck carries a group of musicians and an American flag.

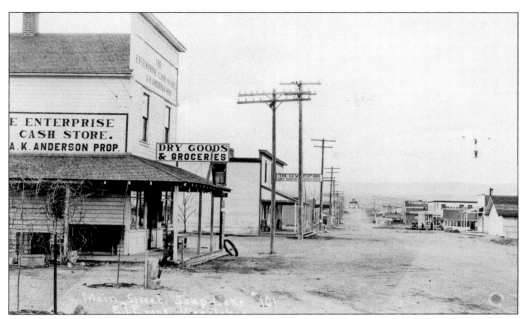

Two dry goods stores operated next door to each other on Main Street. The camera is facing west toward the Sunset Theater, visible at the end of the dirt road. The population of Soap Lake during the summer months of the 1920s through the 1940s was higher than nearby Ephrata, which became the county seat.

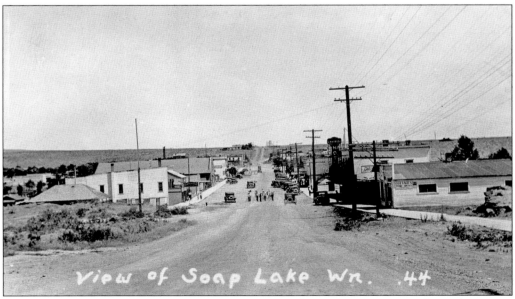

This excellent view looking east on Main street in the late 1900s shows a small parade of men; some appear to have instruments. The James Café and the bakery are on the right.

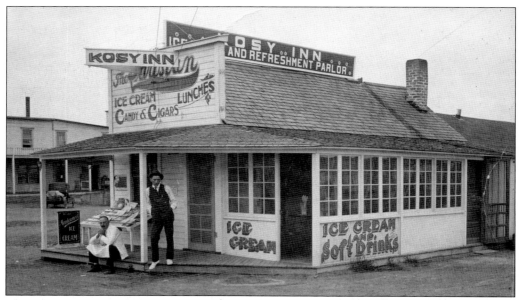

The Kosy Inn was a popular eatery that served ice cream. Remodeled many times and moved at least once, it eventually became a café. Karl Kayson bought it and changed the name to Karl's Kozy Kitchen. (Courtesy of Klasen family archives.)

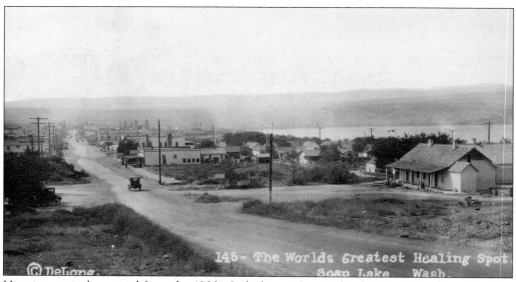

Here is a typical postcard from the 1900s. It declares, "Soap Lake the World's Greatest Healing Spot;" the view is facing west toward Main Street along the primary dirt road that defined the town. Brochures, maps, and tourist guides published by the State of Washington also referred to Soap Lake. (Courtesy of Duane Nycz.)

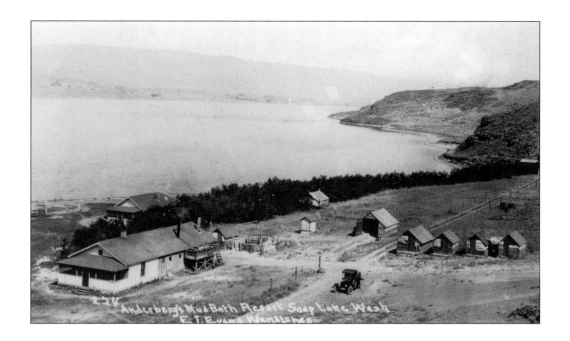

In 1908, O.A. Anderberg began operating his mud bath parlors in tents on the southeast shore of the lake. His practice was to mix Soap Lake water and mud together and heat the concoction before slowly immersing the patient into the tub. Originally called Orchard Cove because of the large apple orchard along the shore, the location was later called Lund's Beach. Anderberg rented tents and sold "deep sea" and mineral water that he shipped throughout the United States.

27

O. A. Anderberg's Mud Baths.

Chemical analysis of Soap Lake water as made by the chemist of the State College at Pullman, Washington:

	PARTS PER 1000
Total Solids	28. 6690
Volatile Solids	0.62503
Non-Volatile Solids	27.64186
Silicia	0.12816
Albumina and Iron Oxide	Trace
Calcium Sulphate	Trace
Calcium Carbonate	Trace
Magnesium Sulphate	0.39089
Sodium Sulphate	6.34872
Sodium Chloride	2.81384
Sodium Carbonate	11.08901
Lithium Sulphate	Trace
Potassium Carbonate	0.51177
Phosphorus Pentoxide	0.1218
Carbon Dioxide (semi combined)	1.37034
Free Ammonia	0.34000
Albuminoide Ammonia	1.10600
Specific Gravity	1.02600

Copy of the Analysis of the mud taken from the property of O. A. Anderberg, by Peter Spaberg:

SiO_2—Silicon Dioxid	Heavy
Fe—Iron	Trace
Al—Aluminum	Trace
Ca—Calcium	Trace
Na—Sodium	Light
K—Potassium	Trace
Cl—Chlorine	Trace
So—Sulphate	Trace
CO_3—Carbonate	Trace

HYPOTHETICAL COMBINATION.

SiO_2—Silicon Dioxide.

NaCl—Sodium Chlorid—Table Salt.

KCl—Potassium Chlorid—Similar to table salt.

$FeSo_4$—Iron Sulphate—Copperas.

$CaCo_3$—Calcium Carbonate—Chalk.

$MgCo_3$—Magnesium Carbonate—A salt used in medicine.

Al_2O_3—Aluminum Oxid—Occurs as Ruby, Corundum and Sapphire, slightly radio active.

O.A. Anderberg produced this card with a certified chemical analysis of the contents of the water and mud of the lake. The analysis was made at the state college in Pullman, Washington.

Four

THE HOTEL BOOM

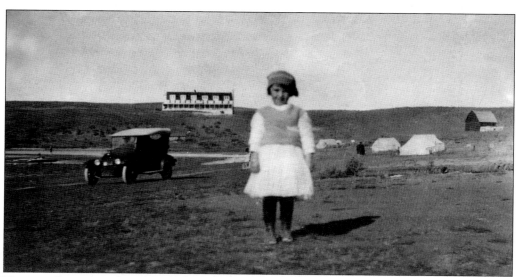

Virginia Grove stands on the beach with the beautiful Siloam Hotel on the hill behind her and several tents in the distance. Virginia grew up in Soap Lake with fond memories of using kerosene to light lamps. She recalled using cardboard from cereal boxes to repair holes in the soles of her shoes.

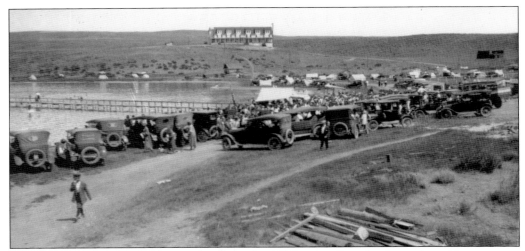

On a busy summer day on the east beach in the 1920s, tents line the shore alongside numerous "Tin Lizzies" (Model As and Ts). The long boardwalk was a popular attraction allowing visitors to walk far out into the shallow water.

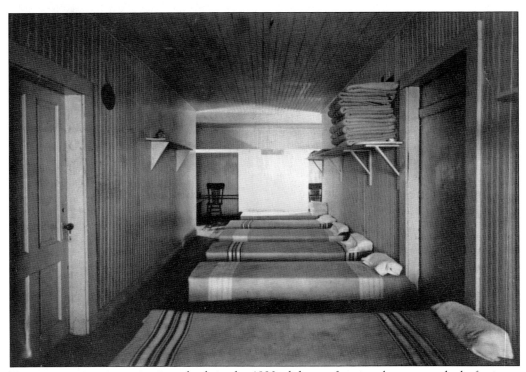

Treatment spaces in sanitariums back in the 1920s did not often involve a great deal of privacy but were organized and had the necessary accoutrements to serve the sick.

Four

THE HOTEL BOOM

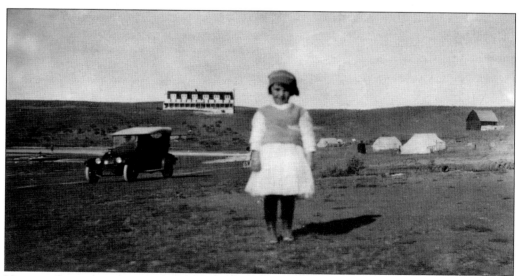

Virginia Grove stands on the beach with the beautiful Siloam Hotel on the hill behind her and several tents in the distance. Virginia grew up in Soap Lake with fond memories of using kerosene to light lamps. She recalled using cardboard from cereal boxes to repair holes in the soles of her shoes.

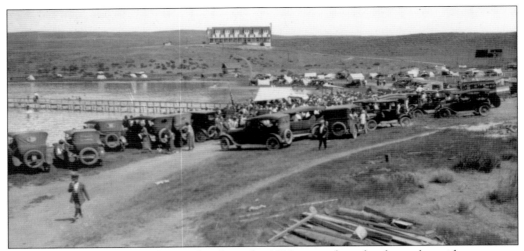

On a busy summer day on the east beach in the 1920s, tents line the shore alongside numerous "Tin Lizzies" (Model As and Ts). The long boardwalk was a popular attraction allowing visitors to walk far out into the shallow water.

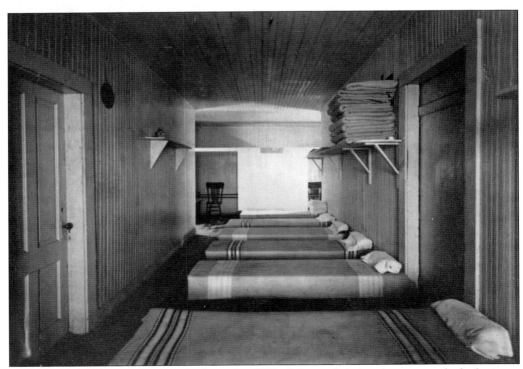

Treatment spaces in sanitariums back in the 1920s did not often involve a great deal of privacy but were organized and had the necessary accoutrements to serve the sick.

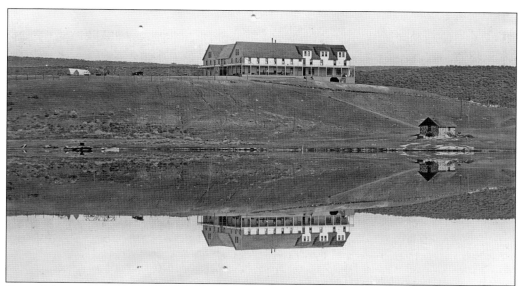

One of the most stunning and beautiful images of the Siloam Hotel portrays its commanding presence on the hill just east of Main Street.

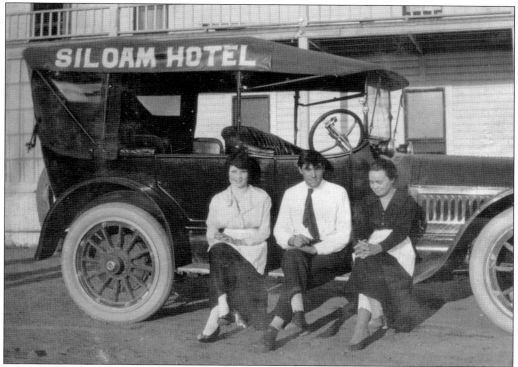

The Siloam Hotel and Sanitarium motor coach is in front of the hotel. On August 4, 1911, the *Grant County Journal* reported the following: "Rev. E.J. Conner, his wife and sister who are the nieces of Chief Joseph are at the lake. His wife is badly afflicted with rheumatism. He is a minister in the Nez Perce reservation. This image does not depict the people in the newspaper posting." (Courtesy of Reed, Darah, Webber, Craig Archives.)

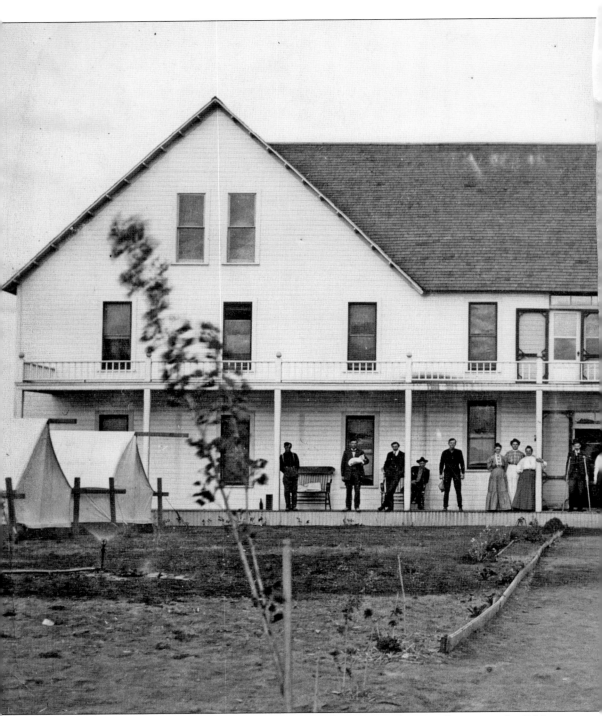

The Siloam Hotel was built in 1906. The name "Siloam" came from a reference in the Bible to the Pool of Siloam near the original city of Jerusalem where Jesus sent a man blind from birth to complete his healing. The beautiful two-story hotel had a commanding view of the lake

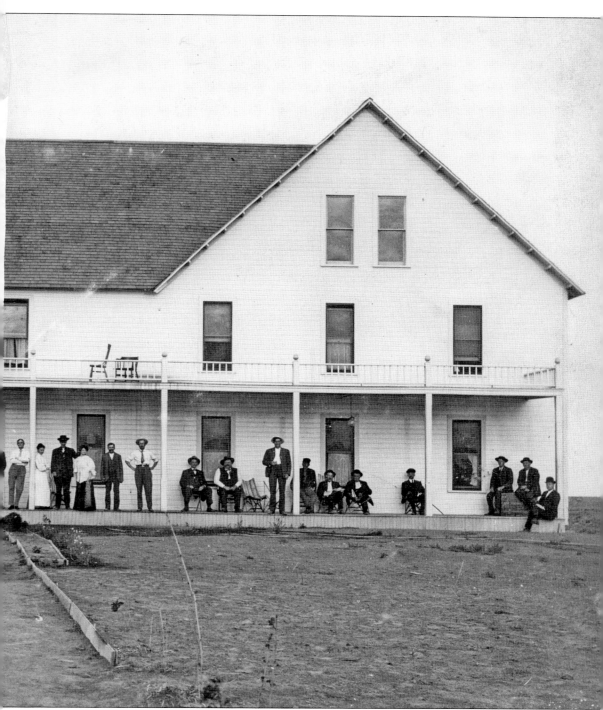

and became known for its distinguished guests. In 1917, the hotel was sold to L.H. Pruitt, who built a sizeable addition to the building, making it the largest hotel in Soap Lake. (Courtesy of Virginia Grove.)

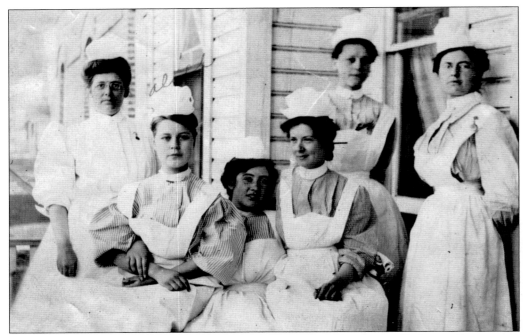

The female staff of the Siloam Hotel followed strict dress codes and professional behavior. Some served as bath attendants for female patients. (Courtesy of Reed, Darah, Webber, Craig Archives.)

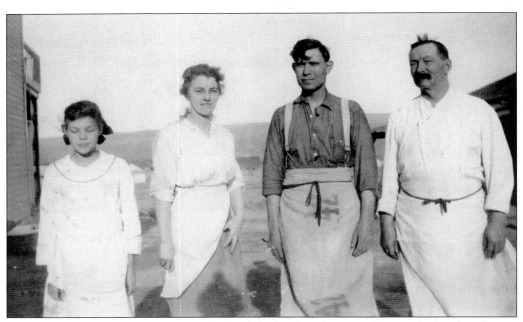

In 1915, Sidney Walter (far right) was the head chef at the Siloam. He later cooked at the Thomas Hotel and Sanitarium. His specialty was ham jambalaya. He died in 1939 in Soap Lake. (Courtesy of Reed, Darah, Webber, Craig Archives.)

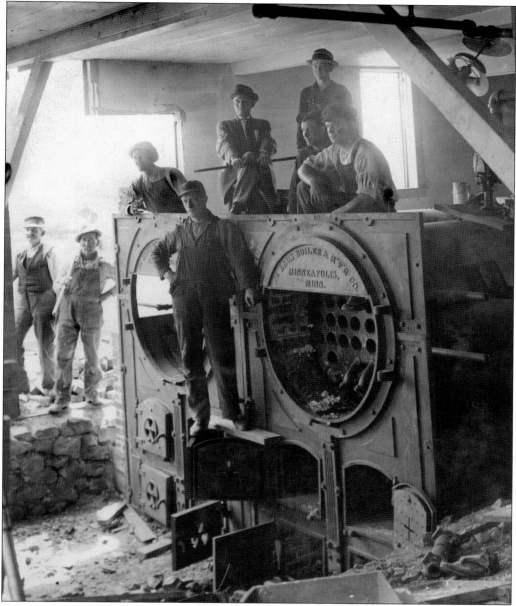

This image from 1910 shows the engine room in the basement of the Siloam Hotel. The hotel was occupied year-round, requiring heat in the winter. Once remodeled to accommodate 100 guests, it took a full-time staff to maintain and operate the hotel infrastructure. (Courtesy of Reed, Darah, Webber, Craig Archives.)

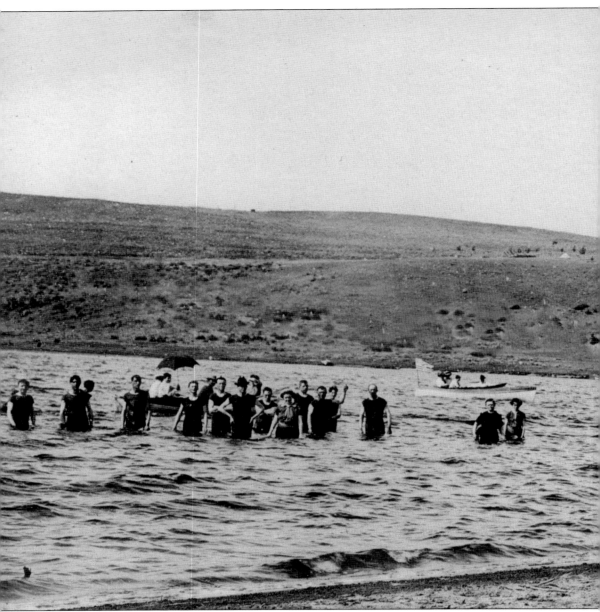

The Siloam Hotel and Sanitarium could be seen from any location in town. On April 11, 1913, the *Grant County Journal* reported the following: "Guests at the Siloam (seen on the hill at the top right) have recently begun the publication of a daily paper entitled, *Soap Lake Nut Factory and Foot Farm News*. At least one edition has been published. It is printed on a Remington

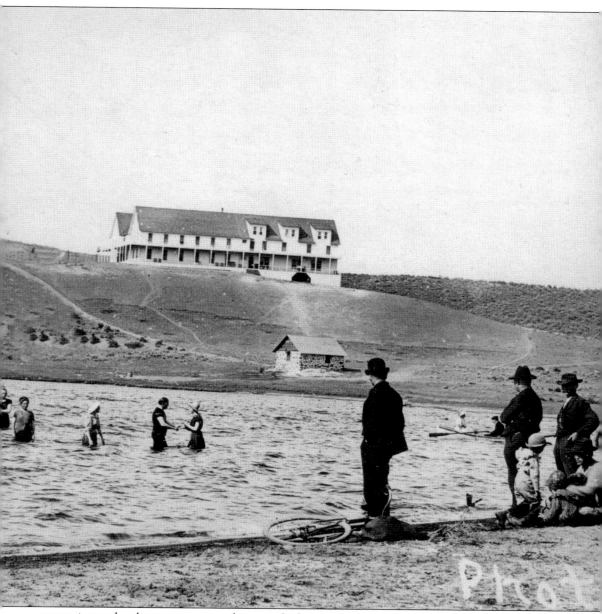

typewriter and carbon copies are made to supply the circulation, although it is hoped that a battery of linotypes and a web perfecting press may be needed in the future to supply the demand. The paper is very amusing and is printed purely for humorous purposes." (Courtesy of Reed, Darah, Webber, Craig Archives.)

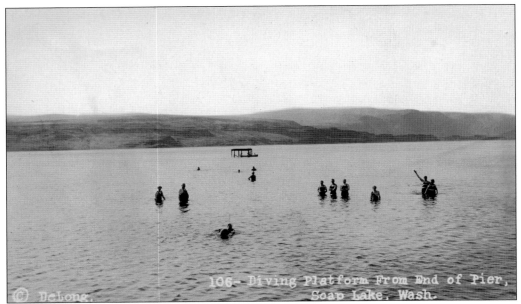

The shorelines around the east and west beaches are shallow. Bathers can walk out into the water for a distance and remain with their head and shoulders above water. The lake was a plunge pool for an ancient waterfall flowing from the north (opposite on the lake from where this photograph was taken). The lake has an oval shape with the deepest part—approximately 125 feet—on the north end. In this image from the 1920s, photographer DeLong points his camera northwest toward the bathers and one of the early diving platforms. The deepest part of the lake is located in the upper right beneath the dark cliffs. (Courtesy of Duane Nycz.)

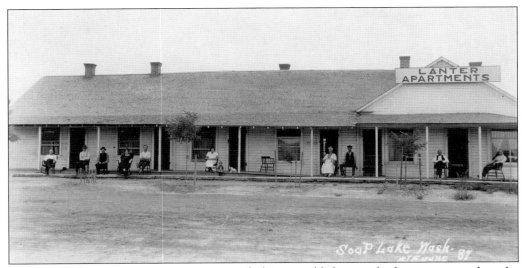

The Lanter Apartments were among many lodging establishments built to accommodate the growing number of visitors at the lake. Many of the apartment facilities and the early cabins were built and managed by people who came to Soap Lake as patients. They started businesses and stayed to help others and to continue using the lake. (Courtesy of Duane Nycz.)

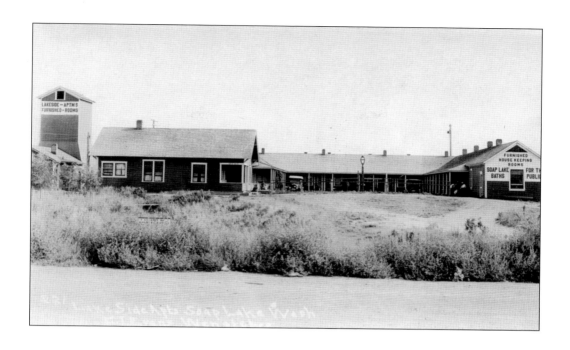

Soap Lake baths were offered at most lodging facilities in town. These are two different images of the Lakeside Apartments. The Lakeside was a popular establishment for those who chose to stay for an extended period of time. (Both, courtesy of Klasen family archives.)

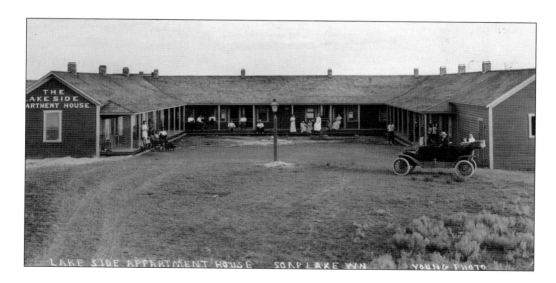

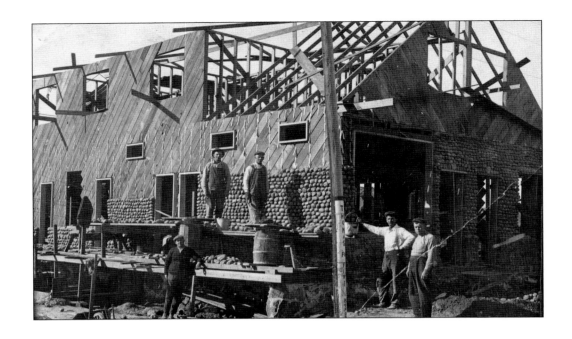

Jack and Pearl Coberly came to Soap Lake in 1904. Jack sought relief from severe psoriasis he had suffered from most of his life. He set to work building the Coberly Apartments, one of the few remaining buildings in town constructed using a plentiful supply of rounded river rocks. There were six rooms upstairs, a barbershop, a doctor's office, and a bathhouse downstairs, and an outhouse in the yard. (Both, courtesy of Betty Coberly.)

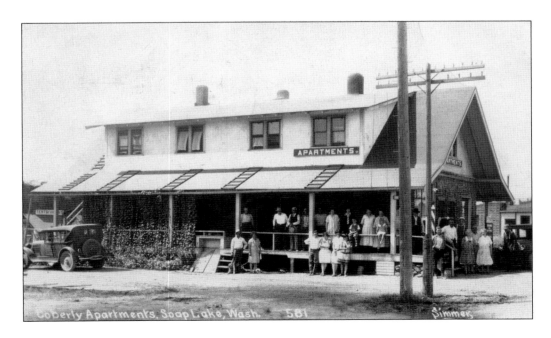

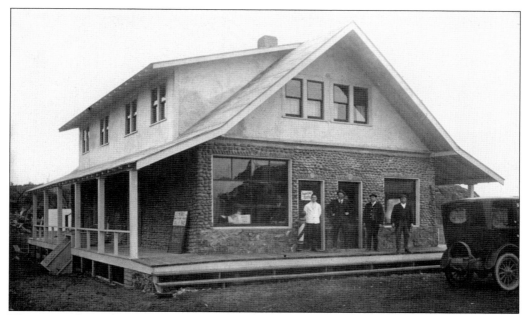

This image shows the front of the Coberly Apartments and the entrance to downstairs the bathhouse. Over the years, different doctors and massage therapists operated their offices next door to the bathhouse. (Courtesy of Betty Coberly.)

Cap Ginnet operated fishing boats in Alaska and had been a sailor most of his life. When he moved to Soap Lake, he started a business offering boat rides around the Lake. Cap was Betty Coberly's grandfather. (Courtesy of Betty Coberly.)

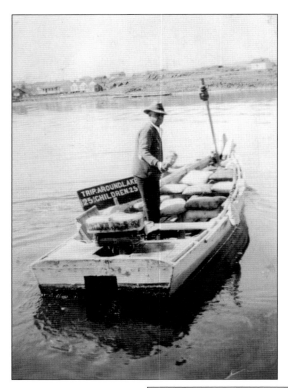

Cap Ginnett gave boat rides and delivered mail to the north end of Soap Lake. Boat rides allowed people to see the cliffs along the northwest shore of the lake. This area was also one of the few places where the green mud could be retrieved. The creamy black mud was most prevalent on the southern end of the lake. (Both, courtesy of Betty Coberly.)

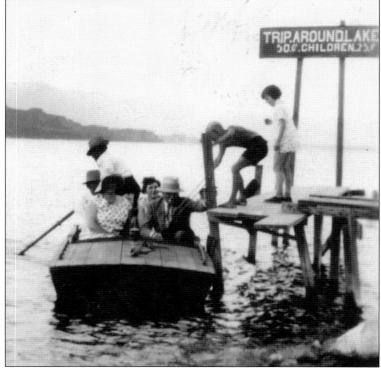

Five

TRAIN STATION AND CHANGE

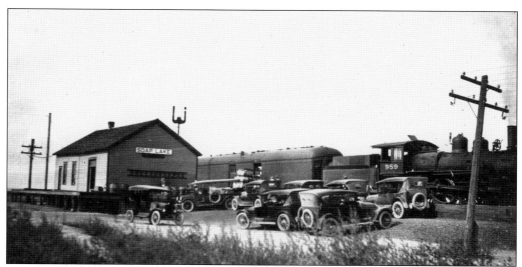

In late 1910, the train began stopping at the new Soap Lake siding instead of leaving passengers six miles away in Ephrata. A road was put in between the station and Soap Lake, and stages began meeting all trains to take passengers to hotels and other lodging facilities. This marked a big change for Soap Lake and especially for passengers arriving on stretchers who would no longer have to take the six-mile journey by horse-drawn carriage or vehicle over dirt roads. (Courtesy of Klasen family archives.)

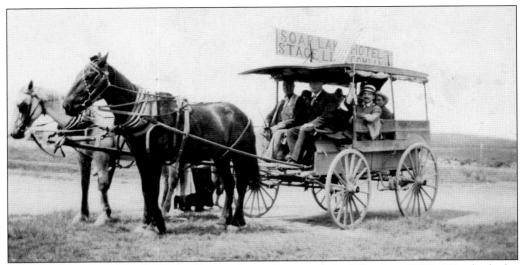

On November 10, 1910, the *Grant County Journal* reported the following: "W.D. Woodard who has been at the Siloam Sanitarium at Soap Lake for the last two months taking treatment for rheumatism has so far regained his health as to be able to take charge of his stage line again." (Courtesy of Duane Nycz.)

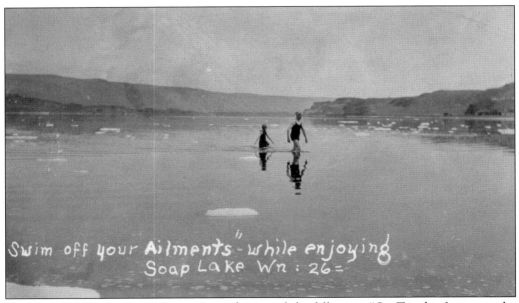

On July 28, 1911, the *Grant County Journal* reported the following: "On Tuesday forenoon, the lake was as placid as a cold pancake on a marble-topped counter, but in the afternoon the wind arose and ripples were noticed. The ripples increased in size as the wind became stronger—just as they always do on the lake." (Courtesy of Klasen family archives.)

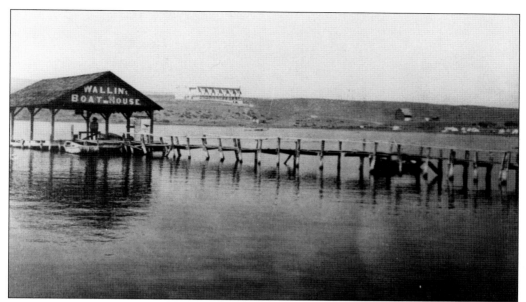

Soap Lake is meromictic, meaning that there are two distinct layers of water that do not mix. The lower layer of water has extremely high mineral content and thus is heavier than the upper layer. Some of the early-day bathhouses and mud bath parlors offered deep-sea baths to their customers. The deep-sea water retrieved from the lower layers of the lake was dark, like coffee, and distinctly odiferous. Baths in deep-sea water were highly regarded because of the strong mineral content. Gus Wallin retrieved deep-sea water from his boathouse for those who paid him for his efforts.

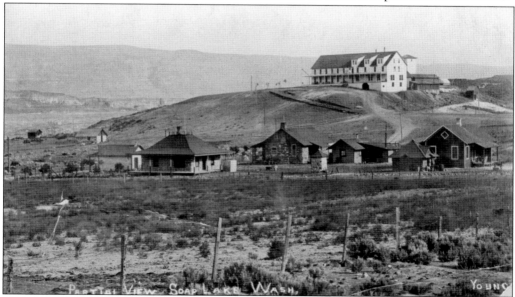

Ray Sellers came to Soap Lake in 1909 from Spokane to be a clerk at the Siloam Hotel and Sanitarium. In a 1957 interview, he talked about life at the Siloam and noted that the hotel was filled to capacity even in the winter. Treatment was simple, he said: "A hot mineral bath a day and a glass of Soap Lake mineral water one half hour before each meal." A doctor who supervised their treatment checked all patients. (Courtesy of Klasen family archives.)

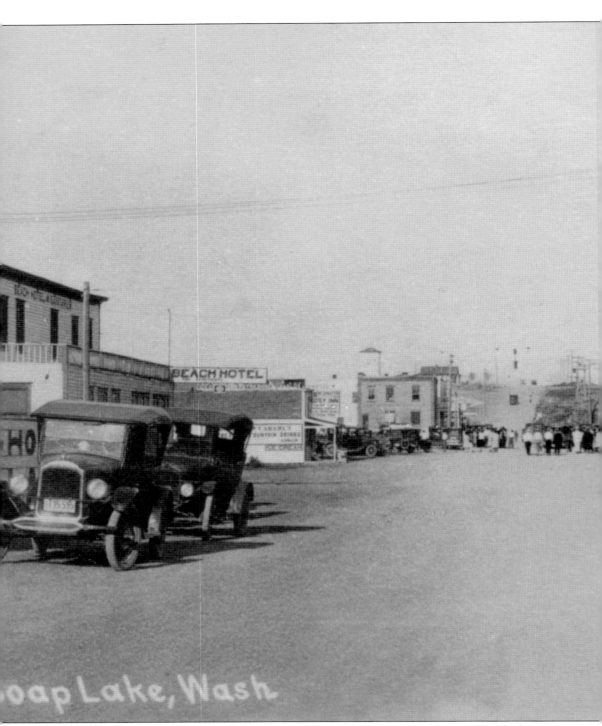

Soap Lake, Wash.

Soap Lake was the most popular resort town in the state. People arrived from across Washington and the Pacific Northwest. By 1914, Soap Lake had four large hotels that could accommodate

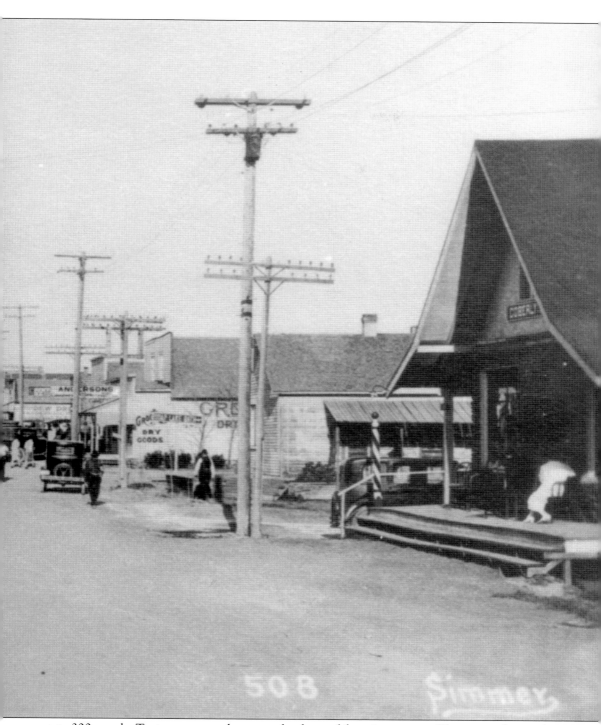

up to 300 people. Tents were rented to meet the demand for private space. There were dry goods stores, restaurants, and several dance halls. (Courtesy of Duane Nycz.)

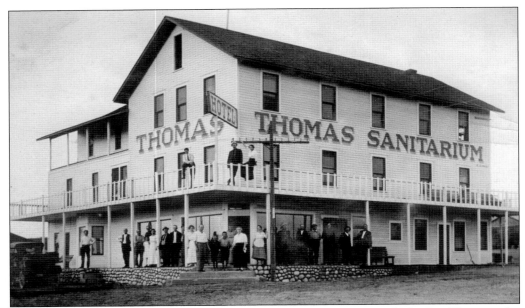

Construction of the Thomas Hotel and Sanitarium began in 1908. Mr. and Mrs. Ben Thomas, who came to Soap Lake from North Dakota in 1905 seeking relief for Ben's skin affliction, built the sanitarium. The original building had 16 rooms but was expanded to meet the growing demand for rooms. It burned down in 1924. (Courtesy of *Soap Lake Heritage*.)

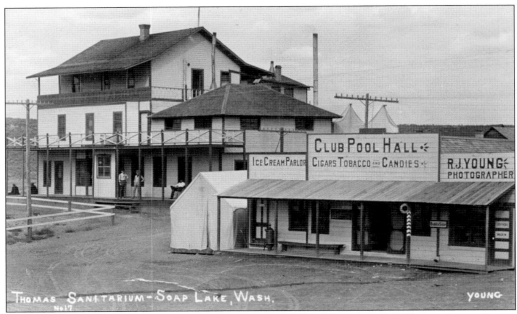

On June 23, 1911, the *Grant County Journal* reported the following: "R.J. Young the proficient photographer is this year located on the corner adjoining the poolroom near the Thomas Sanitarium. Mr. Young does splendid work in photography. He deserves patronage. His office can be seen to the right in this photograph."

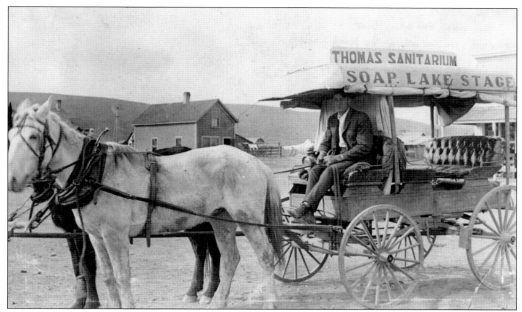

In August 1911, the *Soap Lake Reporter* reported the following: "W.D. Woodward will continue to quote poetry and recite classical essays in his hack to his lady patrons between Soap Lake station and Soap Lake as has been his custom between Ephrata and Soap Lake. Mr. Woodward is powerfully popular and is peculiarly prepared with pertinent and prearranged poetry to please polite and particular persons." (Courtesy of Duane Nycz.)

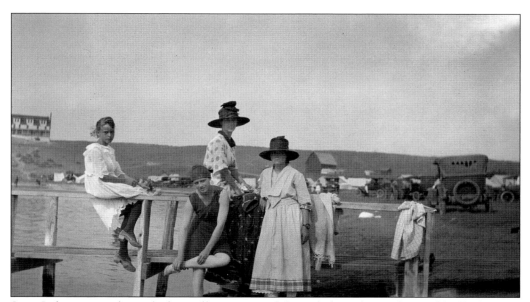

Soap Lake attracted people from all stations in life, including those who could afford a nice hotel and those who camped on free public beaches. Most visitors came for some form of medical treatment or to stay with a friend being treated. (Courtesy of Klasen family archives.)

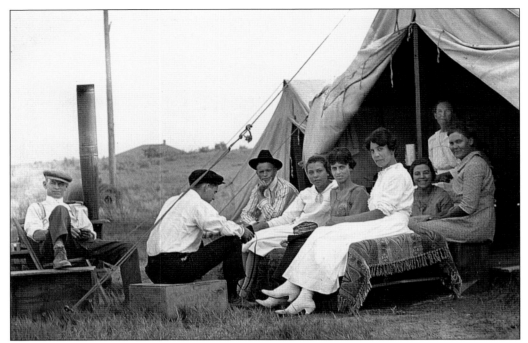

On August 29, 1913, the *Grant County Journal* reported the following: "Among those enjoying themselves on the banks of Soap Lake these warm days are Sen. and Mrs. C.W. Bethel together with Mrs. Bethel's sister, Mrs. W.T. Carmana and Miss Martha Ochs, all of Harrington, who are occupying tents near the Soap Lake Sanitarium. Mr. Bethel is state senator from the Fourteenth District." (Courtesy of Klasen family archives.)

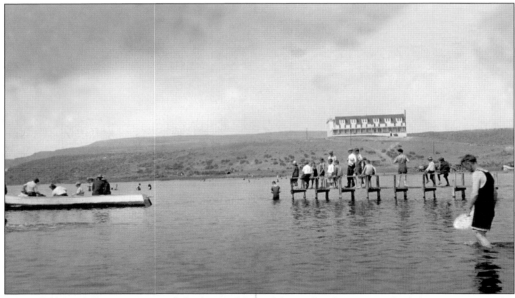

One of many different piers and docks established from the shore into the lake appears on the right side of this photograph. The majestic Siloam Hotel, presiding over the lake, is seen in the upper right. (Courtesy of Duane Nycz.)

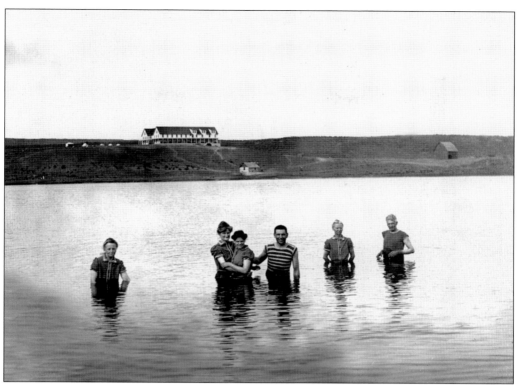

By 1911, Soap Lake was experiencing a record number of visitors. Plans were announced to increase the size of the Siloam Hotel, seen above on the left of the hill. (Courtesy of Duane Nycz.)

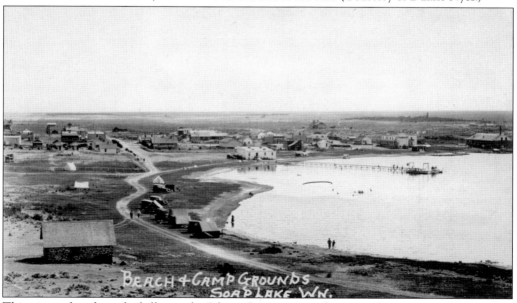

BEACH & CAMP GROUNDS
SOAP LAKE WN.

This view, taken from the hill near the Siloam Sanitarium, is facing southwest across the booming resort town. There is one dirt road heading north out of town to Anderberg's Mud Baths at Orchard Cove. (Courtesy of Duane Nycz.)

TESTIMONIALS

*Cured of Articular Rheumatism and Recommends
Soap Lake Water as the Greatest
Stomach Remedy in the World*

Soap Lake, Wash., June 17, 1913.
To Whom it May Concern:

After having two attacks of acute Rheumatism within a period of seven months and having given the doctor a fair chance to help me, with no benefit to myself, I am now, after having taken Soap Lake treatments for three months, so much better that I have been able to do two months' work during this time and am feeling well and strong and shall always recommend Soap Lake water as beyond a doubt the greatest stomach remedy in the world.

Respectfully yours,
Oscar E. Lee.

*Three Weeks Soap Lake Treatment Cures Bad
Case of Rheumatism and Neuralgia*

Seattle, Wash., June 27, 1913.
Soap Lake Products Co.

Gentlemen:---While living at Vancouver, B. C., I contracted joint Rheumatism. I had it so bad that I had to lie in bed for three months. The joints of my ankles, knees and hands were badly swollen. I could not use them at all. I also had Neuralgia in my head. I had several doctors but they could not help me. After taking three weeks' Soap Lake treatment it has cured my Neuralgia, the swelling has gone out of my limbs and hands and I am able to get around quite comfortably. I think that by following up the treatment I will be entirely cured. You can refer anyone to me who is suffering with Rheumatism and I will gladly tell them what Soap Lake treatment has done for me.

Yours truly,
Mary Jackson,
Hotel Ethelton, Third Ave., Seattle, Wash.

*Tried Hot Lake and Hot Springs. Got More
Relief from Soap Lake Treatment than
Any Other Mineral Water*

Tenakee, Alaska, June, 1913.
I have been crippled with Rheumatism since 1900

There have been countless testimonials solicited and volunteered from people over the years. The author has seen dozens of them. These two pages contain a few that were published in a booklet about the benefits of the lake.

and have visited Hot Lake, Ore., Mt. Clenens, Mich., and Hot Springs, Ark., and I have got more relief and feel better after using Soap Lake treatment than I did from any other mineral water I ever used.

John Eidson.

Cured of Rheumatism and Constipation with Soap Lake Treatment

Wenatchee, Wash., June 5, 1913.

To Soap Lake Products Co., Soap Lake, Wash.

Gentlemen:---When I came to Soap Lake I was all run down with Rheumatism, and Stomach Trouble and Constipation. I am now entirely cured and I give Soap Lake the entire credit.

Ordway Allenbaugh.

Gets Great Relief by Using Soap Lake Treatment for Catarrh of the Stomach

Everett, Wash., July 1, 1913.

To Soap Lake Products Co.:

I have had Catarrh of the Stomach for years, having pain in stomach and could not eat and was greatly distressed at times. After taking Soap Lake treatment I feel greatly relieved and sleep much better.

J. W. Wilbur.

Tower Hotel, Everett.

Sick for Three Years with Neuralgia of Spinal Nerves. Cured with Soap Lake Treatment. Gained Fifty Pounds

Albion, Idaho, June 1, 1913.

To Soap Lake Products Co.:

My husband, Mr. Ed Rosenberg was sick for three years. His trouble was finally pronounced Neuralgia of the Spinal Nerves by the doctor. He was very weak and run down in flesh and weighed less than 140 pounds. He doctored with various doctors for three years without receiving any benefit. On the advice of friends as a last resort I brought him to Soap Lake and after taking the Soap Lake treatment he is now perfectly well, weighs 190 pounds and can do a good day's work and we give Soap Lake treatment all the credit for his recovery. If anyone doubts this statement they can write Mr. Rosenberg at Albion, Idaho, and he will verify my statements.

Mrs. Ed Rosenberg.

Here is part two of testimonials from 1913. This, along with the testimonials on the previous page, was a part of a brochure about Soap Lake.

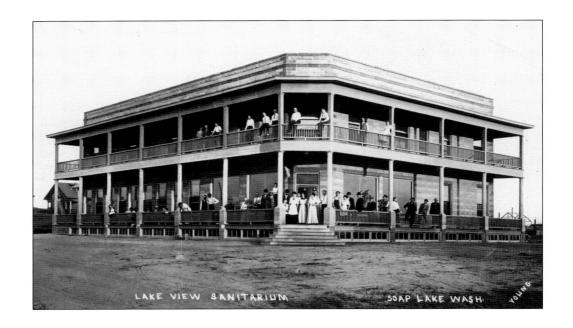

George Krau built the Lakeview Hotel in 1913. On March 26, 1915, the *Grant County Journal* reported the following: "Mr. George Savage, ex-president of the Tacoma Chamber of Commerce was registered at the Lakeview last week. Mr. Savage is one of the real boosters of Soap Lake. Several months ago, he was brought to Soap Lake on a stretcher and made such rapid improvement that he was able to walk in less than two months." (Both, courtesy of Duane Nycz.)

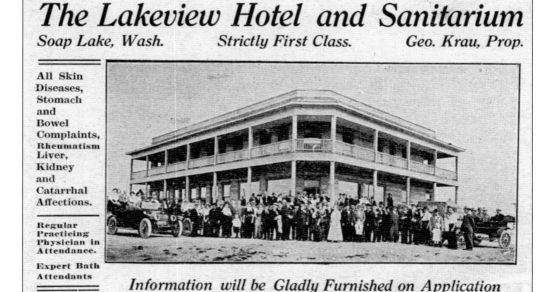

The Lakeview Hotel and Sanitarium
Soap Lake, Wash. Strictly First Class. Geo. Krau, Prop.

All Skin Diseases, Stomach and Bowel Complaints, Rheumatism Liver, Kidney and Catarrhal Affections.

Regular Practicing Physician in Attendance.

Expert Bath Attendants

Information will be Gladly Furnished on Application

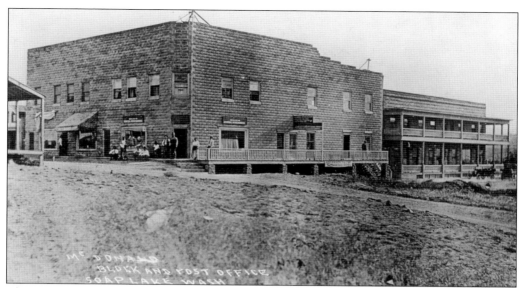

The McDonald Building, completed in 1914, was home to the post office, a ready-to-wear store, a notions counter, a pool hall, a barbershop, public baths, massage rooms, apartments, a butcher shop, and a dance hall. There was a pool in the basement when the building opened, but it was closed within a few months. According to resident Julius Greenwald, the pool was not popular because there were so many sick people around that others shied away from using it. It was soon drained and floored over. (Courtesy of Duane Nycz.)

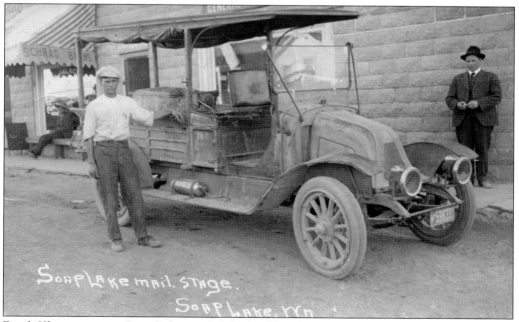

Frank Klasen came to Soap Lake in 1913 for health-related reasons. He began hauling mail by truck from the train station to town. All mail, goods, and supplies for the town arrived by train. There were few roads and only a trail between town and Anderberg's Mud Baths near the southwest shore of the lake. (Courtesy of Klasen family archives.)

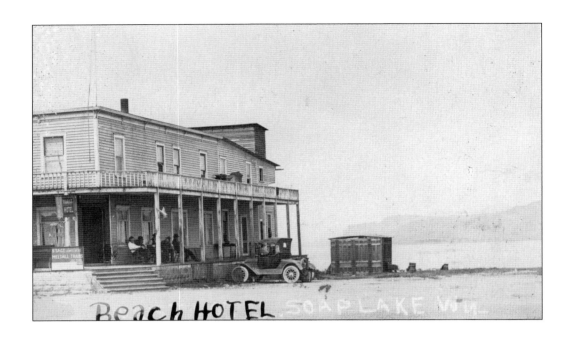

Partners Reiney, Juday, and Johnson built the Beach Hotel, originally called the Tourist, in 1915. When it first opened, a pool hall operated downstairs, and there were a few rooms upstairs. Within a few years, more rooms were added. In 1929, it was partially destroyed by fire. The image above shows how it looked when it was completed; the image below depicts how the Beach Hotel looked after rooms were added. (Both, courtesy of Marina Romary.)

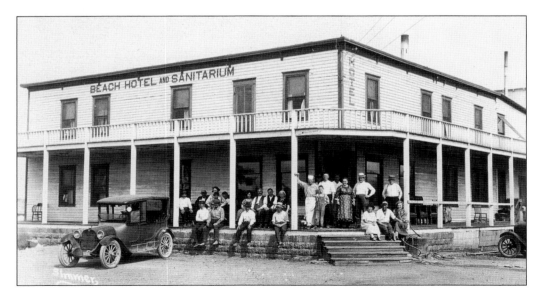

Six

QUEEN OF THE SALT MINE

Roxie Thorson lived longer into the 20th century than any of her compatriots in the early Soap Lake lodging and products manufacturing businesses. She was called the "Queen of the Salt Mine" for her relentless improvements to salt production methods and her long-lived Soap Lake Products mail-order business.

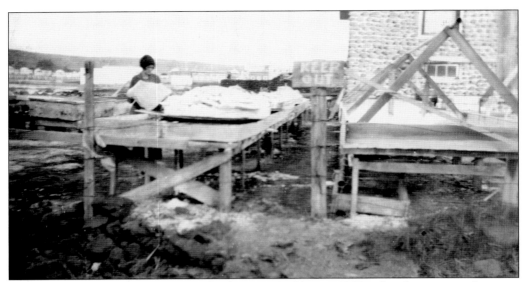

Roxie and her husband, Earnest, bought the Janes Building in 1917 and took over manufacturing of Soap Lake Products. They moved from nearby Ephrata where Earnest was a pharmacist. When Earnest died of pneumonia in 1920, Roxie took over the Soap Lake Products business. She eventually finished the inside of the building and rented rooms and a bathhouse with an attending physician. In the above photograph, Roxie is seen handling large chunks of salt that have been evaporating down before grinding and packaging.

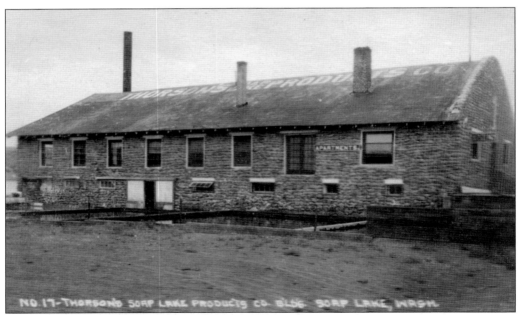

The above is an image of the Janes Building about the time that Roxie and Earnest bought the business. The camera is facing northeast. An evaporation pond is visible alongside the west side of the building. Roxie and Earnest developed one of the most effective evaporation processes that involved the extensive use of settling ponds.

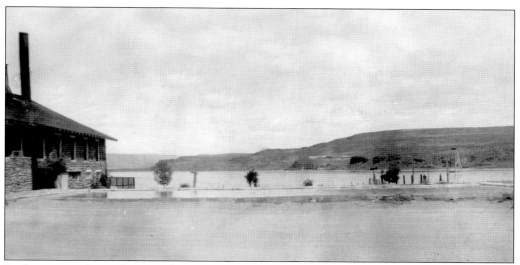

In this image, the settling pond is on the east side of the building but appears to be enlarged. The stack in the upper left side of the frame is the chimney from the boiler plant, located in the back of the building, where the final evaporation process took place.

This view is to the east across the pond with the Beach Hotel in the background. This large pond on the east side of the building was part of Roxie's efforts to learn the most efficient and cost-effective way to manufacture salts while letting the sun do most of the work. Her goal was to get salinity levels of the water in the ponds to a specified level before pumping the pond water into the boiler for the final work. She ultimately used settling ponds on the west side of the building, where the long hot summer afternoons gave the sun unfettered sway over a series of smaller ponds that were directly pumped to the boiler plant a few hundred feet away.

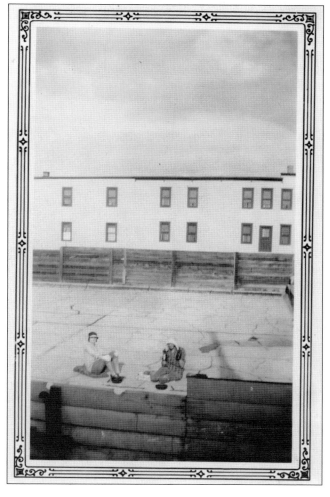

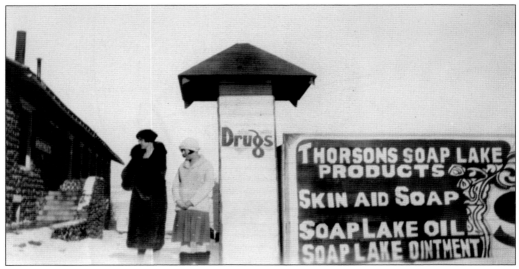

Roxie and her daughter Honora stand alongside one of many different signs that graced the front of the half-block-long property of Thorson's Soap Lake Products Company. Behind the fence on each side of the property were ponds where settling water was evaporated by the sun during the first step of manufacturing salt products.

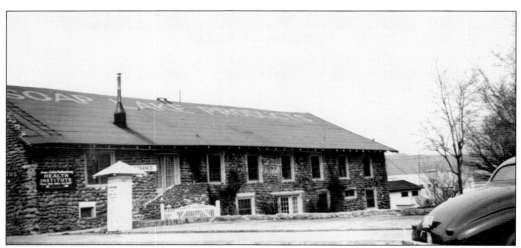

Another view of Thorson's Soap Lake Products shows the building after the apartment remodel, with the pond filled in and the fence removed. The sign on the building to the far left of the image notes: "Soap Lakes Natural-Way Health Institute Where Sick Folks Get Well." There is also a sign for a bathhouse.

R. HAL. BURRISS

PHONE: CADILLAC 2251

2333 CASS AVENUE

DETROIT. MICH.

Jan. 2 1940

Thorson Soap Lake Products Co.,
Soap Lake, Washington

Dear Sirs:

Please enter my order for 100# of your salts. I have
lost your price list and cannot send a check with the
order, therefore, please ship them to me C. O. D.

I have been useing your salts both internally and for
baths for the past year and have wonderful results. In
fact I could not get along without it.

I have Bergers disease and for several years took pavex
treatments at Grace Hospital as well as having a masseur
come to my office daily to rub my foot. For nearly a
year I have had no treatment other than useing the salts
and am now able to walk distances without discomfort,
in fact I am able to play golf again.

I do not know what I would do without the salts and
feel they are the best treatment I could use for my
condition.

Yours very truly,

R Hal Burriss

The letter is one of hundreds from customers who sent testimonies along with notes of gratitude.
Roxie Thorson continued selling Soap Lake Products until her death in 1984.

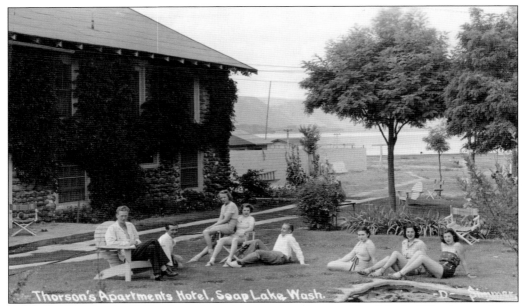

In this image from the 1940s, the early settling pond on the east side of the building is completely filled in. This photograph was taken before the cottages were built in the back to accommodate guests with families. With a bird's–eye view across the lake to the stunning basalt cliffs on the west side of the lake, Thorson's Hotel, now called the Inn at Soap Lake, remains the oldest hotel in the city. Rich in texture and steeped in memories that cling to the impeccably placed cobble rock, the building is a tribute to Roxie and her hard work.

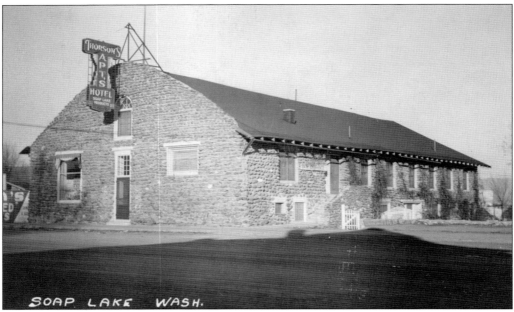

With a new neon sign and the east-side fence gone, Thorson's Apartments, Hotel, and Soap Lake Products Company have withstood the test of time.

Seven

ACCOMMODATING
GROWTH

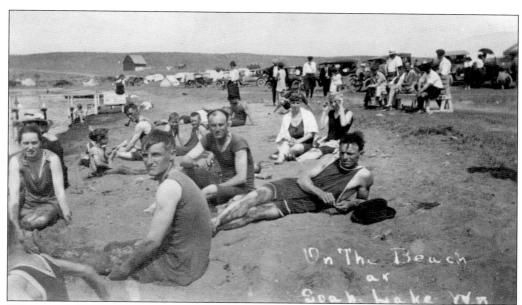

When it came to swimming, the standard attire for both men and women in the early 1900s was a one-piece wool bathing suit. For some people, Soap Lake water is known to cause an abrasive reaction when rubbed between the swimsuit and the skin. More than one person has shared stories of having scars where a wool bathing suit rubbed against their skin after swimming in the lake. Each summer visitors packed the beaches. Room shortages were not uncommon. In 1921, the Bureau of War Risk Insurance officially recognized Soap Lake as a health resort. The government notified the town that it had accepted a proposal that convalescent soldiers who selected Soap Lake could be sent there for treatment and care.

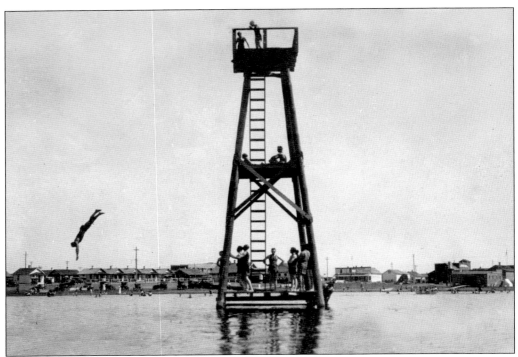

For years, there were walkways and platforms built from the shore into the lake on both the east and west beaches. Several establishments rented bathing suits and lockers and served soft drinks. (Courtesy of Reed, Darah, Webber, Craig Archives.)

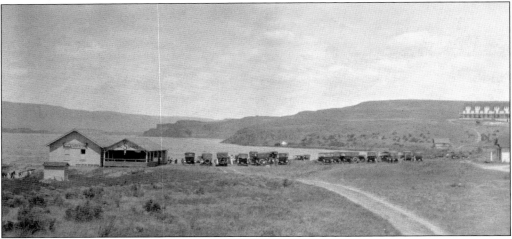

In the Roaring Twenties, Americans had the dance craze. Soap Lake had numerous dance halls and bands that came from Seattle and Spokane. The dance hall in the picture above was located near the east beach. In August 1921, the *Wenatchee World* reported the following: "The Soap Lake Commercial Club dance last Wednesday evening was a great success both as a social and financial affair. Promptly at 9:00 p.m. Thornhill's Jazz-A-Way orchestra from Wenatchee, composed of real peppy and accomplished musicians, struck up with one of the choicest selections which seemed to put new life into the rheumatics and some one hundred couples kept the floor busy until after midnight." (Courtesy of Duane Nycz.)

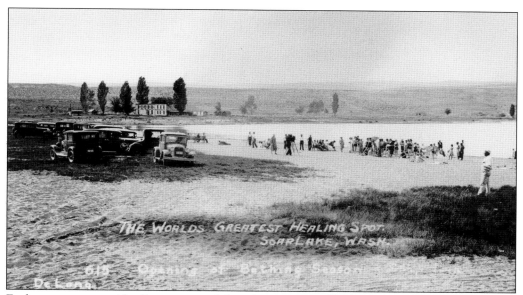

Each year, on a specifically announced day, the opening of bathing season was declared, and an official photograph was made to mark the occasion. Above, photographer DeLong captures the action of a fellow photographer preparing to record the annual event. (Courtesy of Klasen family archives.)

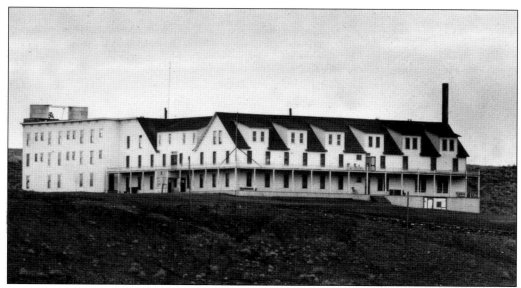

By 1913, the Siloam Hotel had expanded to accommodate the growing number of visitors. In the above photograph, the expansion is evident, making it the town's largest and most visible hotel, capable of lodging over 100 guests. (Courtesy of Klasen family archives.)

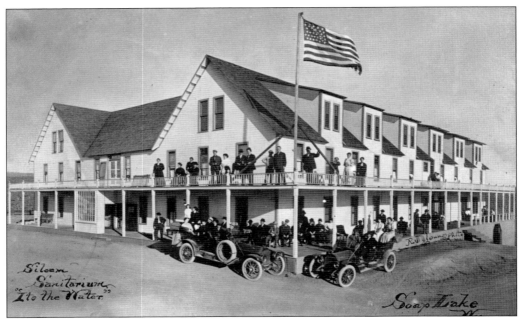

The Siloam Hotel is seen in full glory after the addition. On February 16, 1912, the *Grant County Journal* reported the following: "The Siloam is crowded again this week; every room in this popular hotel has been taken." (Courtesy of Klasen family archives.)

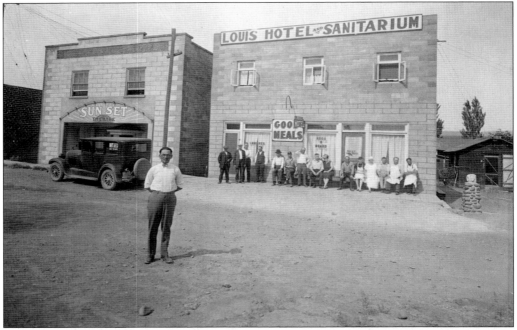

In 1919, Louis Agranoff built the Louis Hotel and Sanitarium. Casting each brick by hand, he built the hotel one block at a time. It was well known among the Jewish community in Seattle that another Jewish family owned the Louis Hotel, and by virtue of that fact, the hotel became a special gathering place for their community when visiting Soap Lake. (Courtesy of Julian Agranoff.)

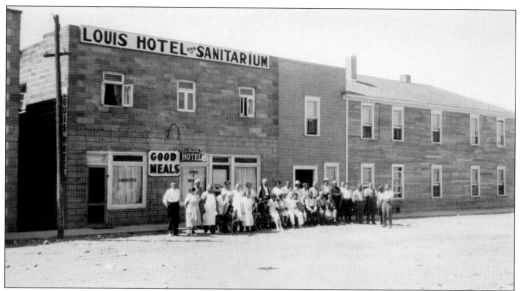

Louis Agranoff later added rooms to his establishment by dragging the Johnson Hotel from nearby Ephrata. In so doing he damaged the county road and had to pay for repairs. (Courtesy of Julian Agranoff.)

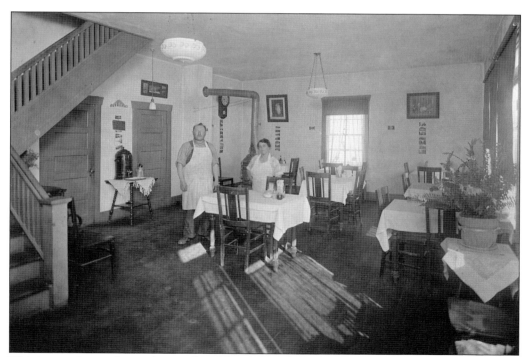

This image depicts Louis Agranoff and his wife, Julia, in the dining room at the Louis Hotel. During the Depression, small business owners often had to be their own cooks and housemaids. (Courtesy of Julian Agranoff.)

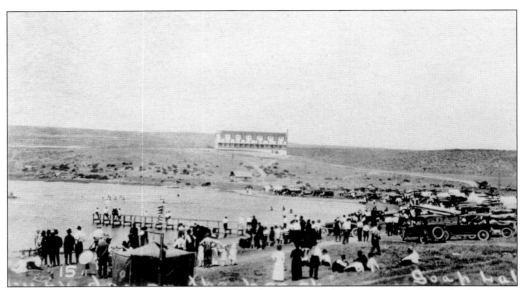

This image portrays a typical day on the beach in Soap Lake in about 1915. With their "Tin Lizzies" lining the beach, lots of people in their Sunday best, as well as a flag and a few bicycles, are visible. (Courtesy of Duane Nycz.)

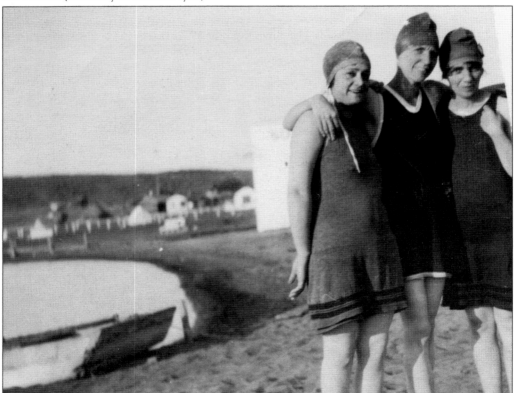

This photograph depicts typical bathing attire for women—knee-length wool bathing suits and rubber caps for the head—in the 1900s. Several shops along the beach rented suits and caps.

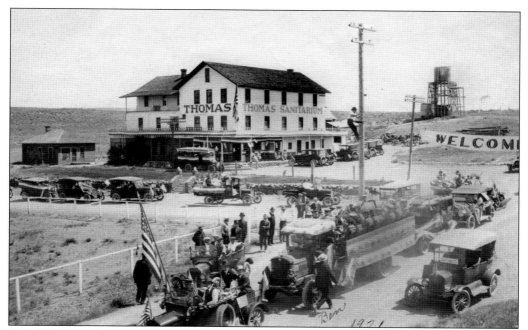

Soap Lake was the most popular place in Grant County to spend the Fourth of July. Hotel and café owners, dance hall operators, and the Soap Lake Commercial Club made sure there was plenty of food and fun for the crowds. Headlines from the 1920s indicate that it was not unusual for 1,000 people to attend the festivities. (Courtesy of Duane Nycz.)

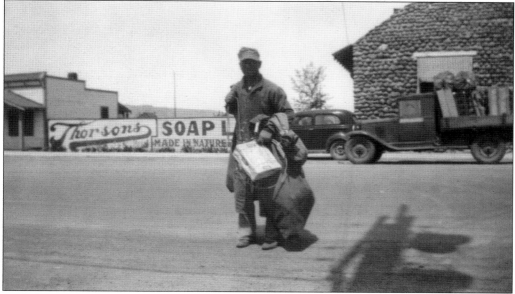

Paul Klasen Sr. came to Soap Lake in 1919 to visit his brother Frank. There was no electricity in town, each hotel had its own generator, and kerosene lamps lit the streets at night. Paul eventually took over the mail route and met trains at the Soap Lake station twice a day. He would also deliver passengers to the sanitariums, including passengers arriving on stretchers. (Courtesy of Klasen family archives.)

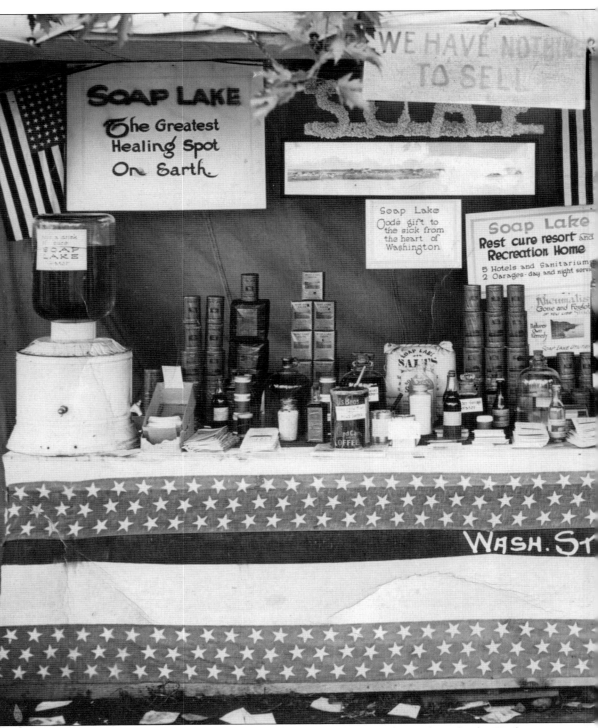

The Soap Lake Commercial Club arranged this display of Soap Lake products for the Washington State Fair in 1920. Among the signs in the display is one that reads, "God's Gift to the sick from

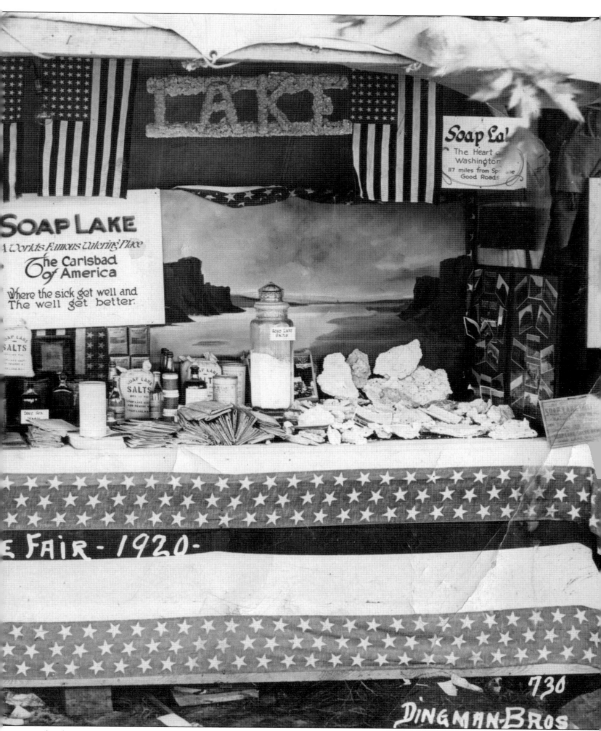

the heart of Washington."

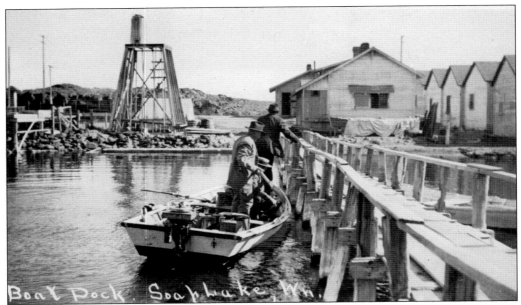

The above boat dock was located on the east beach near the salt factory. Boats were used to deliver goods and mail to the north end of the lake, where there was a small post office and a few residents. Boats were also used to retrieve deep-sea water from the north end of the lake. (Courtesy of Duane Nycz.)

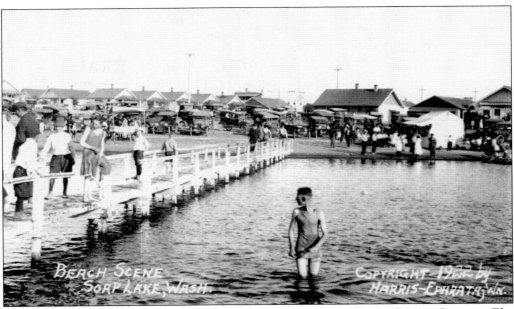

Here is another image of the pier located on the east beach near the Beach View Cottages. The long shallow water on the shore of the lake made it easy for piers to be erected. The harsh mineral qualities of the lake prevented any of the structures from surviving over the years. There are none left today. (Courtesy of Duane Nycz.)

DR. C. W. McCONKEY

OSTEOPATHIC PHYSICIAN AND SURGEON

ENTERPRISE CASH STORE

Everything to Eat and Wear — Fuel and Ice

SOAP LAKE MUD BATHS
CHAS. McKEEGAN, PROP.

LADY ATTENDANT SHOWERS AND SWEATS

BEACH HOTEL AND SANITARIUM

$2.50 per Day and Up includieg Board, Room
and Bath. Open the Year Round.

HOT AND COLD WATER, STEAM HEAT AND
ELECTRIC LIGHTS

JOE ROSIN, Proprietor

WE ARE CATERING TO YOU
WE MEET ALL TRAINS
WRITE OR WIRE FOR RESERVATIONS
DR. C. W. McCONKEY, Medical Director

THOMAS HOTEL & SANITARIUM
A GOOD PLACE TO STOP
RATES--Including Board, Room and Bath
$2.00 to $3.00 per Day

SCHRAG & SCHRAG
Soap Lake's Pioneer Doctors
Sons of the Famous Dr. J. R. Schrag

EXAMINATION FREE

DR. J. B. EDWARDS
Women's Disorders Rheumatic Specialist
36 Years Experience
COBERLY APARTMENTS

Lake View Hotel & Sanitarium
GEORGE KRAU, Proprietor

MIKE HULA'S COTTAGES
Three Rooms Furnished, Including Bath

Modern First-Class
Write for Reservation

This list of businesses and services offered in Soap Lake in the 1920s is a small cross section of what was available at the time. None of these businesses are in operation today.

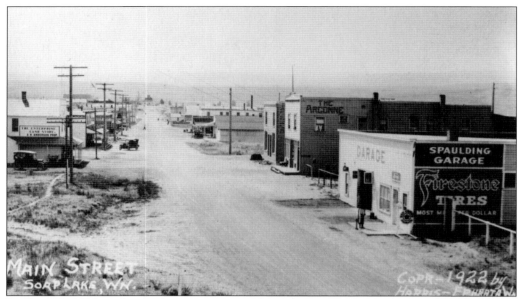

In the early 1920s, a dirt road ran east to west through Soap Lake. There was talk of building a state highway that would pass through town heading north. The main dirt road in this photograph continued to the east and then north toward a place called High Hill. The Spalding Garage on the right serviced Model A and Model T cars as well as equipment for nearby farmers. The Argonne Hotel, situated west of the garage, was another lodging facility in town; it later became the Waltho Hotel and Sanitarium. (Courtesy of Duane Nycz.)

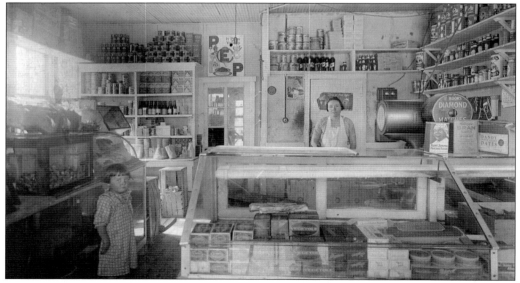

Joyce Bonthius-Pinkerton is shown inside her parents' first grocery store in Soap Lake. Joyce grew up in Soap Lake. In the following from 2010 interview, she shared some of her favorite memories: "In the winters of 1930–1940 the lake would freeze so hard that cars could drive on it. There was at least one adult who would drive a car on the ice pulling children on sleds behind them. She recalled one time having large bonfires on the lake ice. One of her favorite memories was watching the suds on the lake, especially at night when there was a play of light on them."

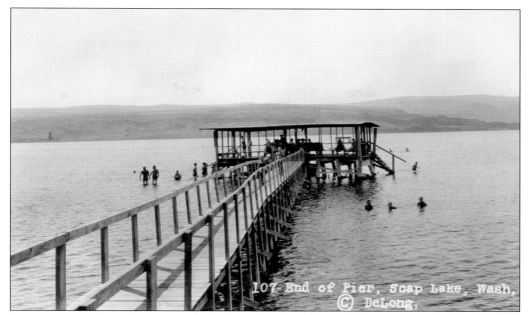

Every few years, the walkways and diving boards at the lake would be maintained and expanded. This image depicts the most elaborate walkway of all, including a shaded pavilion at the end and a stairway into the water. Other than a few stubs of decayed wood and some corroded steel cables and pipes, there is nothing left of these beautiful walkways and covered resting areas.

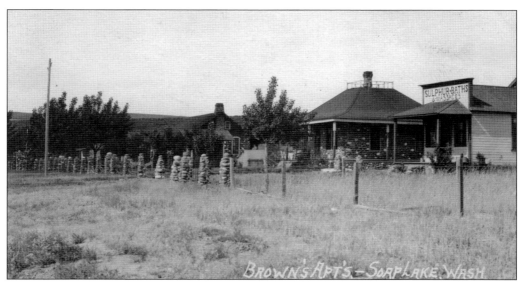

There are several round river rock houses in Soap Lake built by E. Paul Janes. Most of them remain standing to this day along with some of the decorative vertical rock "pilings." Note the Sulfur (spelled sulphur) Baths sign on the house to the right of the rock building.

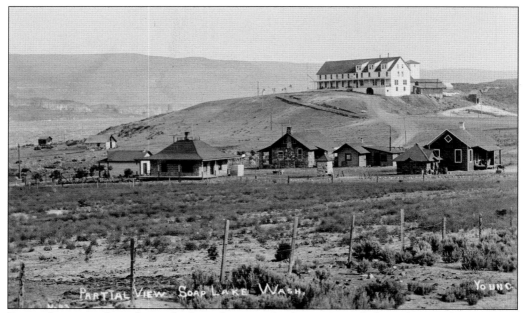

Pictured are several new homes built on the east side of Main Street below Siloam Hill. Two of the homes were built with rounded river cobble. One was the office of E. Paul Janes when he was operating his Soap Lake Products and real estate businesses in town. (Courtesy of Duane Nycz.)

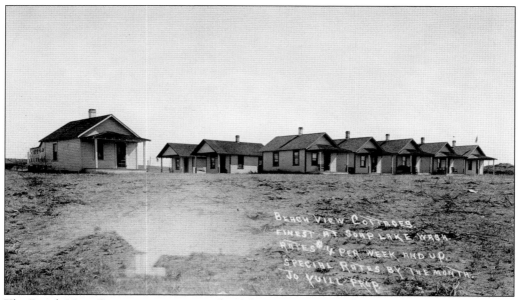

The Beach View Cottages are an example of the many cottages that were built in Soap Lake in the 1920s and 1930s. On January 23, 1931, the *Grant County Journal* reported the following: "Mr. and Mrs. Cullett of Monitor are guests at the Beachview Cottages. Mr. Cullett while snipping off part of a tree had the misfortune to let the shears rest over an uncovered wire. He reached for them and fell striking the concrete underneath the ladder and suffered serious injuries; however he is doing better at this writing." (Courtesy of Duane Nycz.)

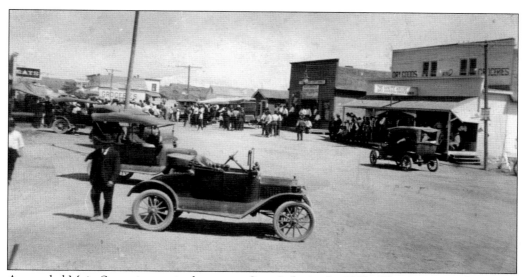

A crowded Main Street is seen in downtown Soap Lake in the 1920s. The American flag waves in front of an establishment that sells ice cream, soft drinks, nuts, candies, cigars, tobacco, and ice. To the right is the White House Dry Goods and Grocery Store. (Courtesy of Duane Nycz.)

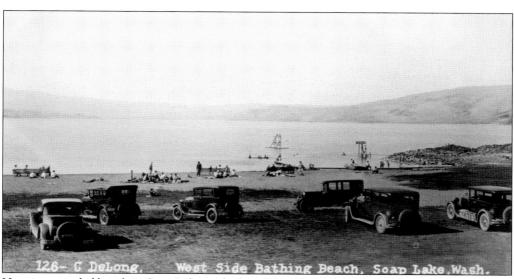

126- C DeLong. West Side Bathing Beach, Soap Lake,Wash.

Here is a crowded beach in Soap Lake in the late 1920s. Ford Model A cars are in the foreground, and the small platform where Cap Ginnett loaded people into boats for a trip around the lake is on the right side of the image. (Courtesy of Duane Nycz.)

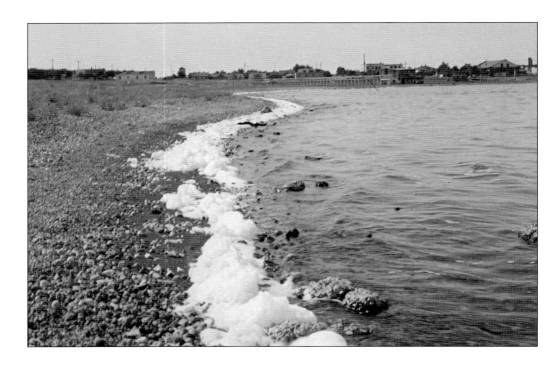

The sudsy, thick foam that forms along the shore of the lake is legendary. Stories have been told about clumps of foam as big as a car blowing across the lake. While no photograph exists of suds that large, one can still see up to foot-high piles of white foam along the shore after a strong north wind blows across the lake. Having the same appearance as dish soapsuds, it is one of the most distinguishing, though fluctuating, visual features of the lake for those lucky enough to catch it, usually early morning in the spring or fall. (Both, courtesy of Joyce Pinkerton.)

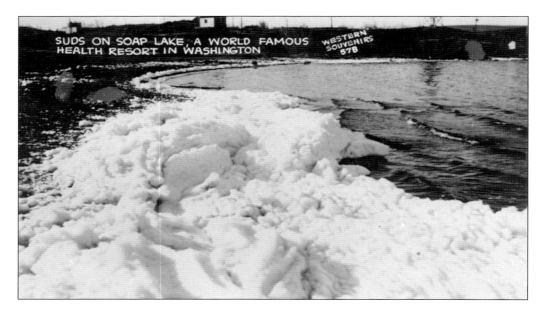

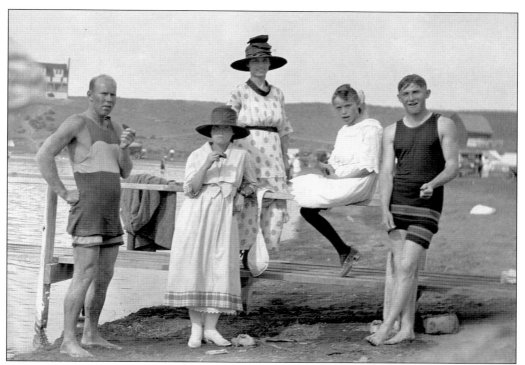

Standing by the east beach pier is a family on a Sunday outing, the men are wearing customary one-piece wool bathing suits. (Courtesy of Klasen family archives.)

Here is another crowded beach scene on a Sunday in the summer at Soap Lake. Men wearing dress shirts and slacks mingle with others in one-piece wool bathing suits. (Courtesy Duane Nycz.)

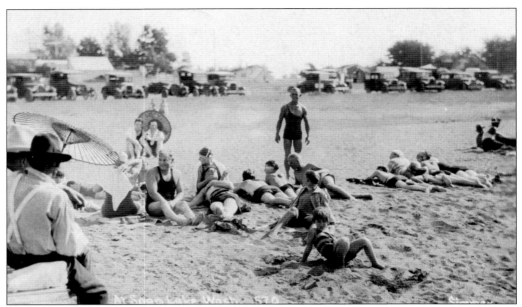

On August 4, 1911, the *Grant County Journal* reported the following: "The rule now prevails that anyone who may be seen bathing in the lake, unless dressed in a proper bathing suit shall be arrested. Some carelessness on the part of individual bathers has compelled authorities to adopt this measure." (Courtesy of Klasen family archives.)

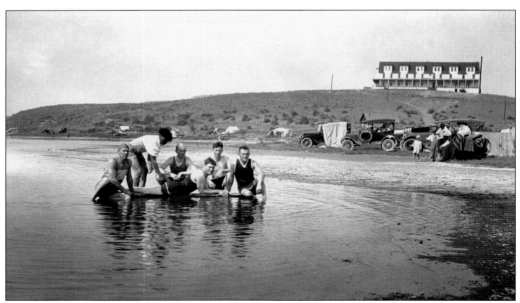

On April 26, 1915, the *Grant County Journal* reported the following: "Thirty-five guests are registered at the Siloam [above right], and the Manager George Chinn says he is well pleased with the business outlook. One of his guests is A.R. Cross of Chicago." (Courtesy of the Klasen family archives.)

On August 4, 1911, the *Grant County Journal* reported the following: "The temperature of the lake seemed to be just right on Tuesday for the bathers, after the rain of Monday night." (Courtesy of Duane Nycz.)

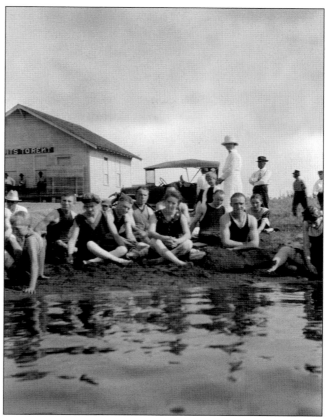

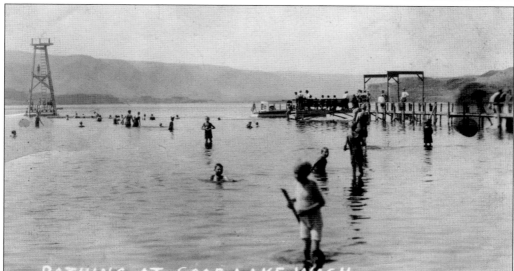

On April 2, 1915, the *Grant County Journal* reported the following: "The weather has been charming for the past week and some intrepid spirits of both sexes have been seen cavorting themselves in the lake. Miss M. Brown has the honor of being the first lady to swim in the lake this year." (Courtesy of Klasen family archives.)

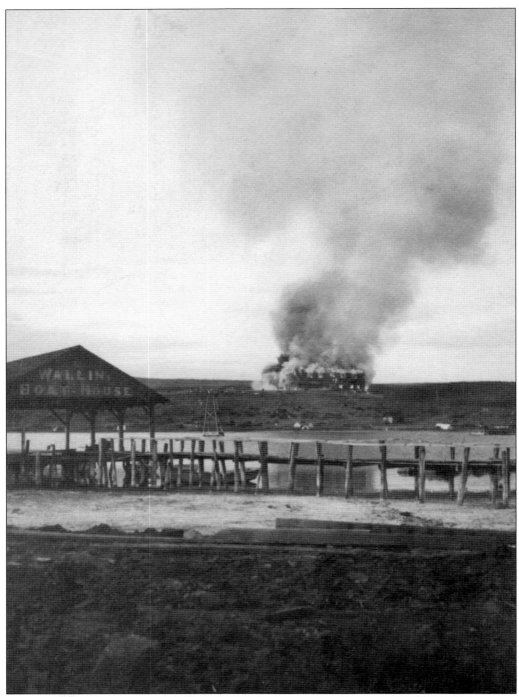

Tragedy struck on September 2, 1921, when the Siloam Sanitarium burned to the ground. The proprietor was burning weeds at the time; the building was destroyed. No lives were lost. Having no insurance, it was never rebuilt. What is left of the broken foundation remains on the hillside to this day. (Courtesy of Klasen family archives.)

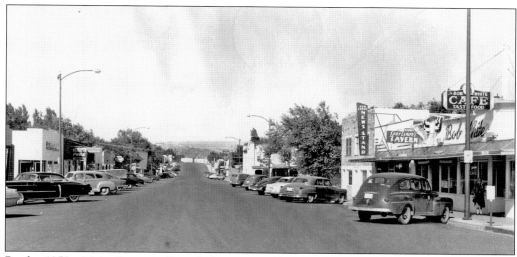

By the 1950s, Main Street in Soap Lake was paved. Downtown businesses included a bowling alley, a newsstand, taverns, a pharmacy, a grocery store, restaurants, massage parlors, and a few bathhouses. The Bob White Café on the right is now the location of the Sundial Bistro.

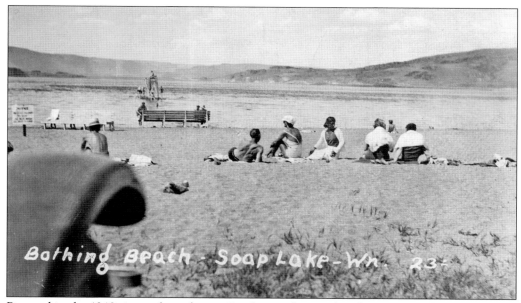

Pictured in the 1940s is another relaxing Sunday on the west beach. Gone are the wool bathing suits but not the relaxed atmosphere of people enjoying themselves on a sunny day. Note the diving board to the left.

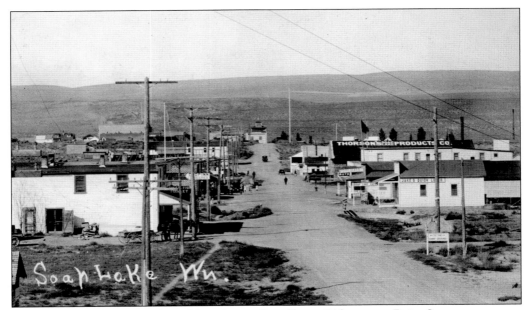

This is a view looking west down Main Street. State Route 17, known as Daisy Street, now passes north and south right about where the sign is that points to the campground. Soap Lake Café is just east of where Don's Restaurant is located today. Note the large sign on the roof of Thorson's Hotel and Soap Lake Products Company.

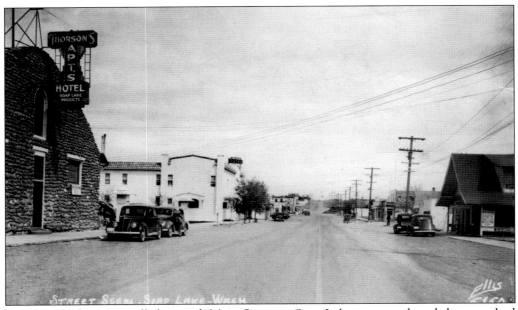

By the time the 1930s rolled around, Main Street in Soap Lake was paved, and the town had electricity and streetlights. The Grand Coulee Scenic Highway was built, and more traffic was moving north and south through town. (Courtesy of Klasen family archives.)

Hotel
Devonshire

335 STOCKTON STREET
SAN FRANCISCO, CALIF.

January 5th 19ʒ 1940

Thorsen's Soap Lake SALT Co
Soap Lake, Washington.

Gentlemen;

Replying to your of recent date as to the results Inwas getting from using Soap Lake Salts would say that I have been using the Salts since 1920 and since that time have found it beneficial for many things.

I started first using it for a bad case of itch which Doctors had treated for three months giving me no relief. After three Soap Lake Baths I was completely healed. I have seen marvelous cures made it a very short time of poison ivy and an old case of eczema.

I am convinced that it will cure most any kind of skin trouble and also use it to regulate the bowels. I make it a point to always have a supply on hand and will soon be ordering another fifty pounds.

With kindest regards, I am,
Yours truly,

S. A. Bliss

S D BLISS
346 Sutter Street
San Francisco, Calif.

Visit the GOLDEN GATE INTERNATIONAL EXPOSITION *on San Francisco Bay*

This letter is an example of the hundreds of testimonials collected by Roxie Thorson over the years. Many who visited the lake would continue to receive the benefits of the mineral waters by ordering products from Roxie throughout the year.

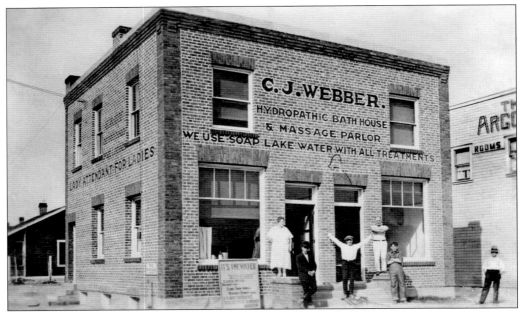

The C.J. Webber Building was located on Main Street along the new Grand Coulee Scenic Highway. Note the Argonne Hotel to the right. On June 24, 1931, the *Grant County Journal* reported the following: "The following are taking baths and treatments at Jack Webber's: Mrs. Augusta Peterson, Spokane; Mrs. E. Olson, Seattle; F. Peterson, Seattle; A.J. Legate, Alaska; Gertrude Wilson, Selah; Robert Swanson, Seattle; John Swanson, Seattle; A.F. Liebert, Seattle; W.L. Harrison, Wenatchee; F.L. Hardy, Tacoma; Mrs. Mattie Howeattle, Taholah; Mrs. H.W. Beer, Victoria; Assunta Paris, Seattle; Rosy Fadizo, Seattle." (Courtesy of George Waltho.)

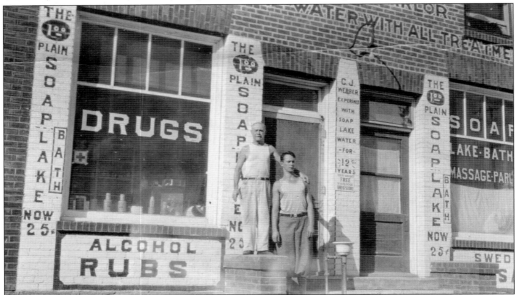

The above photograph is a close-up of the C.J. Webber Building after the windows were painted and a pharmacist added to the services offered, which included baths and massage. (Courtesy of Reed, Durah, Webber, Craig Archives.)

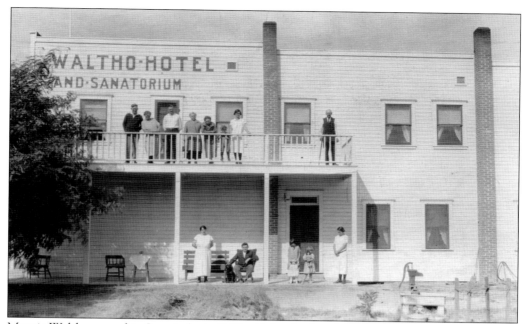

Maggie Waltho moved to Soap Lake in 1923 with her husband. Soon afterwards, they purchased the Argonne Hotel and transformed it into the Waltho Hotel and Sanitarium. Maggie is standing next to her husband on the ground to the left. (Courtesy of George Waltho.)

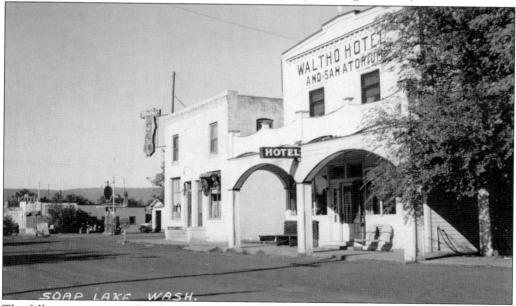

The following note was found on the back of a Waltho Hotel postcard, dated August 17, 1944: "Hello all. Arrived at 4 yesterday. Slept from 7 last nite til 9 today. Sure is hot here so far. Saw Dr. last nite. Start treatments this afternoon. Room here is $20 a week so am staying just 2 nites. Write me at gen. del. This is a nice town. I was the only one of 5 that arrived who had reservations. I know I will like it here. Dr. said 2 weeks was all I need to stay. Sure have a cold. How are you Vi. Love Altos." (Courtesy of George Waltho.)

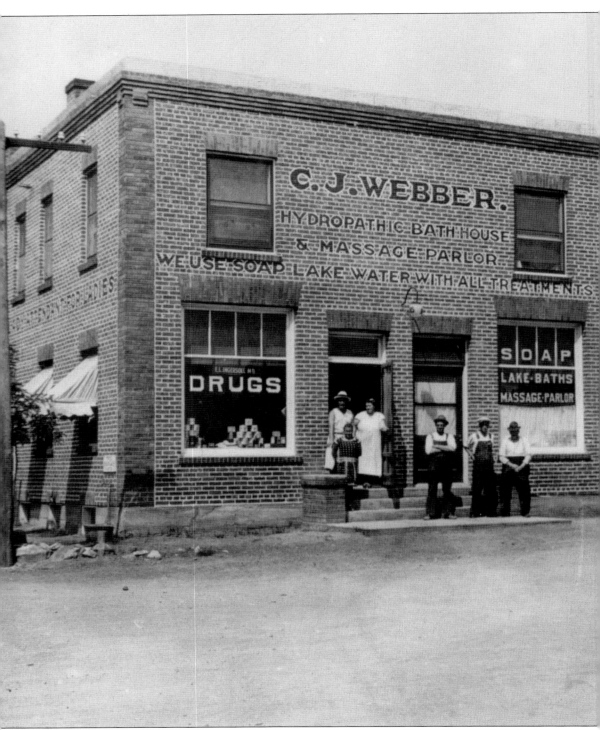

This image from the 1930s shows the transformation of the corner of Main Street and the highway. The C.J. Webber Building (now the Soap Lake Art Museum) sits on the corner with a mural

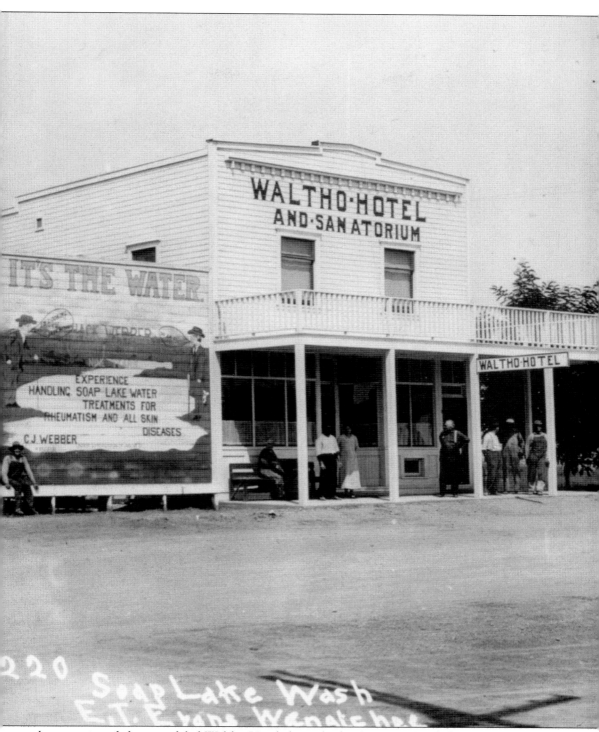

between it and the remodeled Waltho Hotel, formerly the Argonne Hotel. (Courtesy of Reed, Durah, Webber, Craig Archives.)

Jack Webber also owned apartments where he offered Soap Lake baths and massage. Webber had several businesses in Soap Lake and is another example of someone who came to the lake for treatment and stayed to start a business. (Courtesy of Reed, Durah, Webber, Craig Archives.)

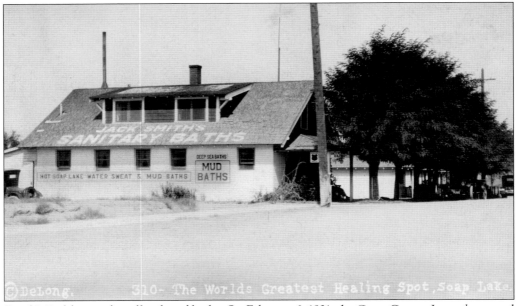

Smith's Bathhouse also offered mud baths. On February 6, 1931, the *Grant County Journal* reported the following: "W. Deathrige, manager of the Smith Mud Baths went to Wenatchee Saturday to purchase new mud bath tubs and plumbing fixtures. Mr. Crowley has been taking mud baths there and returned home to Ellensburg with his health greatly improved. Mrs. Mosely is also showing great improvement from her treatments there." (Courtesy of Duane Nycz.)

Eight

Buerger's Disease

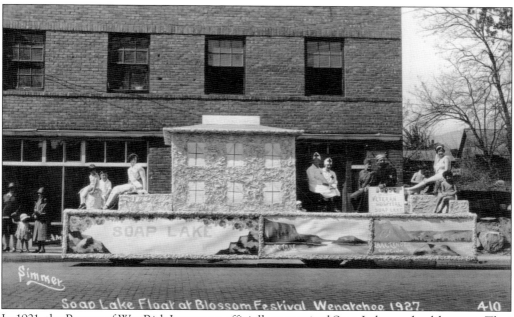

Soap Lake Float at Blossom Festival Wenatchee 1927.

In 1921, the Bureau of War Risk Insurance officially recognized Soap Lake as a health resort. That meant veterans from any foreign war could obtain treatment from sanitariums at Soap Lake. In this photograph from a 1927 parade, the Soap Lake float carries several bathing beauties, nurses, and veterans. The poster reads, "Boost Veterans Hospital Soap Lake." This marks the early efforts by veterans groups to build a hospital in Soap Lake for the treatment of Buerger's disease.

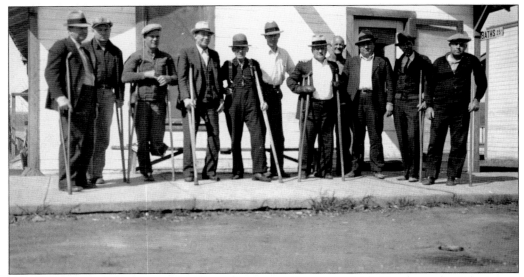

Buerger's disease (*Thromboangitis obliterans*) is a rare disease in which blood vessels of the hands and feet become blocked. The result is rotting of the flesh, exposure of nerves, and excruciating pain. The only treatment is amputation. An untold number of veterans returning from World War I had the disease. By the early 1920s, veterans discovered that Soap Lake provided relief from the onslaught of the disease. The patients in this photograph were veterans who came to Soap Lake for treatment of Buerger's disease. (Courtesy of Klasen family archives.)

Earl McKay, a World War I veteran, came to Soap Lake for treatment. He, along with Bill Williamson and many other veterans and support groups, many including wives of veterans, began years of lobbying through local legislators, the Veterans of Foreign Wars, and the American Legion to establish a federally funded hospital in Soap Lake that would treat Buerger's disease. In February 1934, the federal government authorized $10,000 to fund a study on the use of the lake water to treat the disease. (Courtesy of Marina Romary.)

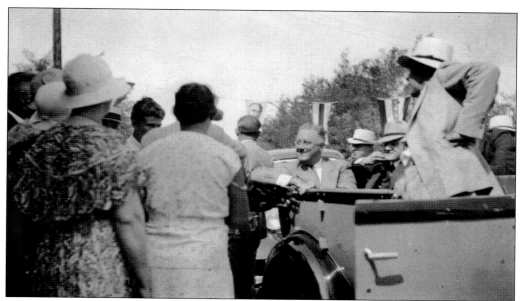

On August 4, 1934, Pres. Franklin Roosevelt passed through Soap Lake on his way to visit progress at Grand Coulee Dam. Many veterans were in town to show their appreciation and support of the president, whose administration authorized money to support the cause of Soap Lake and its role in helping Buerger's patients. Many also lined the street to show support for the president's program to build Grand Coulee Dam and the possibility it would include the Columbia Basin Irrigation Project. (Courtesy of Elaine Mullinex.)

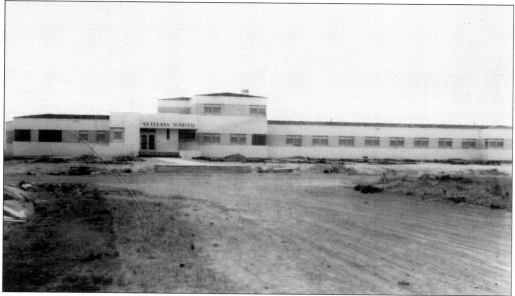

Ultimately, it was the State of Washington that funded the new hospital. The state authorized legislation and funding to buy property and build a hospital in Soap Lake for research and treatment of Buerger's disease. On November 11, 1938 (Armistice Day), Washington governor Clarence Martin was joined by over 500 people for the dedication ceremonies at the new hospital. Governor Martin declared, "There is only one Soap Lake in America."

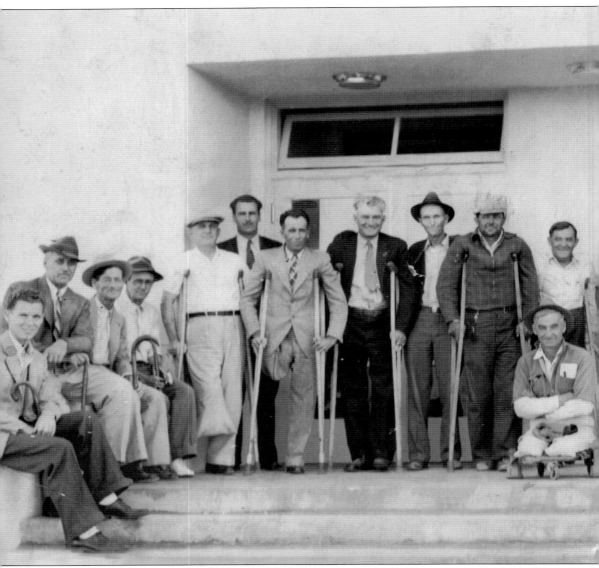

Gayle Ogan of Helena, Montana, provided this photograph to the *Grant County Journal*. Taken on October 8, 1939, it shows some of the first patients at McKay Memorial Hospital. All of them were amputees with Buerger's disease. Though most of their first names and spellings were not known, Ogan listed the patients as, from left to right, Albert Haugen, ? Crane, ? Lope, ? Walker,

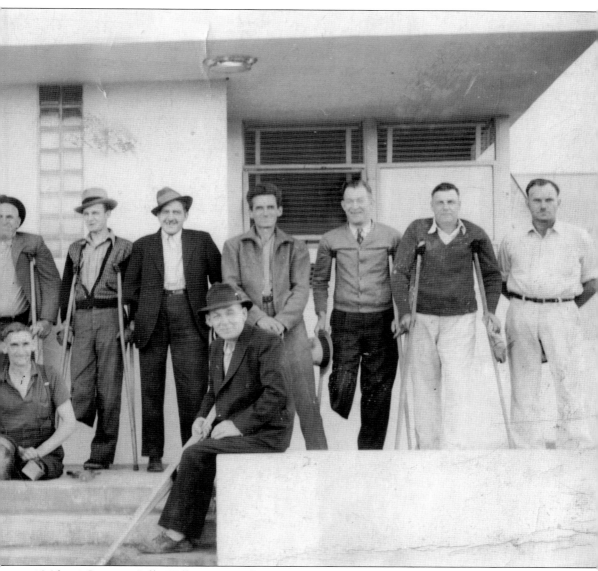

? Miles, ? Gorman, Billy Williamson, ? Thompson, ? Smith, ? Heard, Carl Turner, J. Nelson, Bill Castle, ? Sasse, E. Lemon, ? Wills, A. Thompson, ? Long, ? Seerow, H. Stuart, ? Fitzgerald, and ? Crane. (Courtesy of the Klasen family archives.)

TO WHOM THIS MAY CONCERN:

I wish to make the following statement in regard to the benefit my mother, Mrs. Margaret Storey, received during her sojourn at Soap Lake, and also by the daily use of Thorson's Soap Lake Salts after returning to her home.

My mother had been afflicted with Berger's disease for a period of ten years. Three years ago she had a toe amputated, and at this time we came to the conclusion that she could never again go through such an ordeal. In January, 1935 another toe became sore, and as the last resort we took mother to Soap Lake in April. The toe immediately started to heal, and the terrific pain subsided. After a month at Soap Lake, she returned to her home and after a period of three months, during which time her feet were bathed twice daily with Thorson's Soap Lake Salts, the toe healed completely and the flesh actually grew on the toe.

I can give only the highest of praise to Soap Lake, and the work Mrs. Roxie Thorson is doing with the Soap Lake Salts.

I will personally verify this statement, and will be only too glad to answer any questions in regard to Mother's recovery and the wonderful results obtained from Soap Lake and the use of Thorson's Soap Lake Salts.

Mary J. Storey

State of Washington
County of King
Subscribed and sworn before me
this 3rd day of July, 1936

Notary Public in and for the State of
Washington residing at Seattle.

This notarized letter, written in July 1936, is another example of hundreds of testimonies sent to Roxie Thorson over the years. In this example, the writer expresses details about the effectiveness of Soap Lake on treating her mother who had Buerger's disease.

Nine

GROWING UP IN
SOAP LAKE

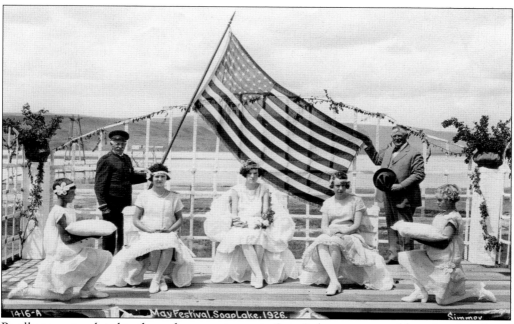

By all accounts related to the author, growing up in Soap Lake was memorable and a whole lot of fun. Children were included in every festival in town, whether it was for the Fourth of July; May Day, which was celebrated in the 1920s and 1930s; or Suds 'N Sun in the 1950s and 1960s. Many of the people who came to Soap Lake for treatment of a health problem would stay and start a business. Many of the people who owned business establishments portrayed in the photographs in this book had children who grew up in Soap Lake. As the years have passed, many of the children left, but their children and their children's children still visit.

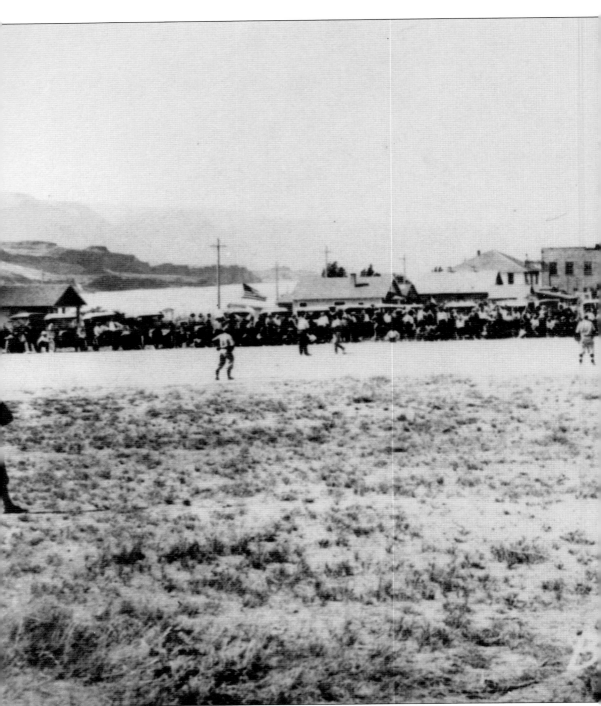

The citizens of Soap Lake loved baseball. The grandstand in the Soap Lake ball field had the capacity to seat 300 people, with room for cars to park along the perimeter of the field. The sport was wildly popular, and the Soap Lake team won many games against nearby Ephrata, Wilson Creek, Odessa, Adrian, Quincy, and Neppel (later known as Moses Lake). Team members in 1911

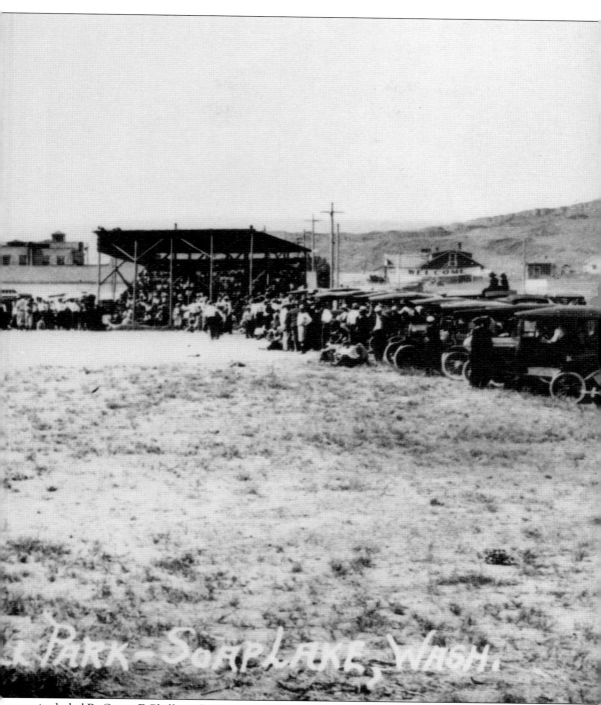

PARK—SOAP LAKE, WASH.

included R. Ogan, F. Phillips, C. Duncan, W. Ogan, Southworth, P. Lowe, G. DeBolt, ? Nygreen, and O. DeBolt. The field was located in the area where the Soap Lake Gardens is now located. This is just east of the McKay Healthcare and Rehab facility and alongside Division Street. (Courtesy of Klasen family archives.)

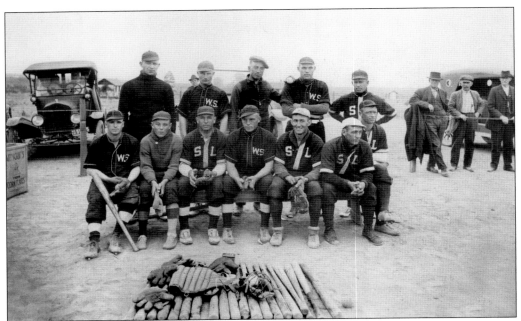

This early photograph of the popular Soap Lake baseball team includes some unidentified people. It is known that Larry Scheib is in the back row, second from the right, and that Paul Klasen Sr. is third from the left in the front row. Paul Klasen Sr. told his son, "the Scheibs were the best ball players around." (Courtesy of the Klasen family archives.)

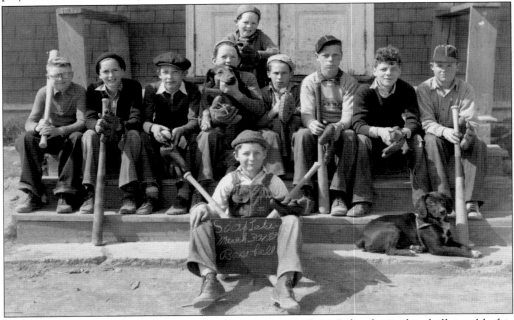

Paul Klasen Jr., on the lower step with two bats, grew up in Soap Lake playing baseball, just like his dad. His friends, many whom helped him tip over outhouses in town, include the following, from left to right: Paul Hampen, Bruce Zwaschka, ? Weiss, George Waltho, Leo Handley in back, Les Morton, Clarence Vuckle, Thompson and unidentified. (Courtesy of the Klasen family archives.)

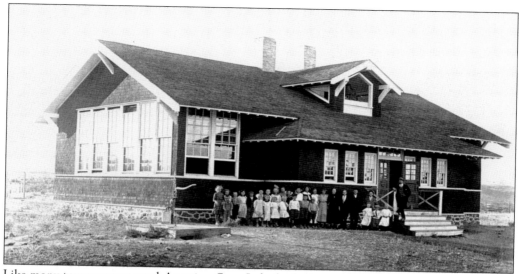

Like many towns across rural America, Soap Lake had a one-room schoolhouse with a potbelly stove. The school taught students through grade eight. (Courtesy of Klasen family archives.)

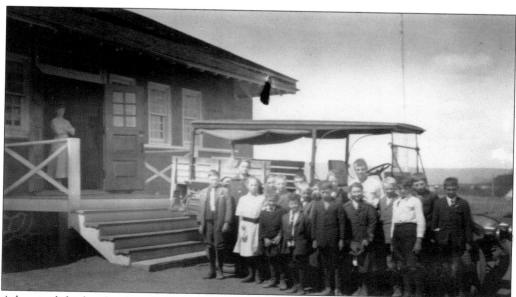

A bus took high school students to nearby Ephrata. This practice continued until 1959, when Soap Lake got its own high school, and students could attend all 12 grades in town. (Courtesy of Klasen family archives.)

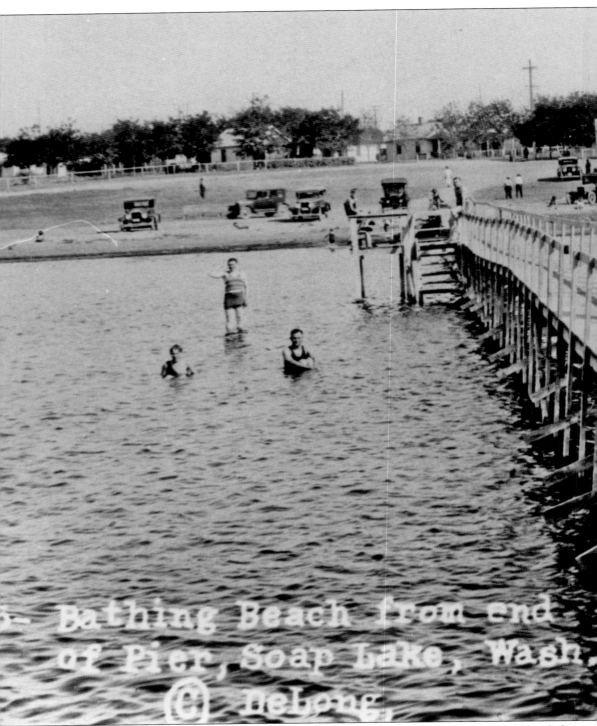

Bathing Beach from end of Pier, Soap Lake, Wash. © DeLong

One fond memory recalled by youngsters growing up in Soap Lake was of the walkways that led into the lake. Jumping off the end of the walkway and playing hide and seek in the water among

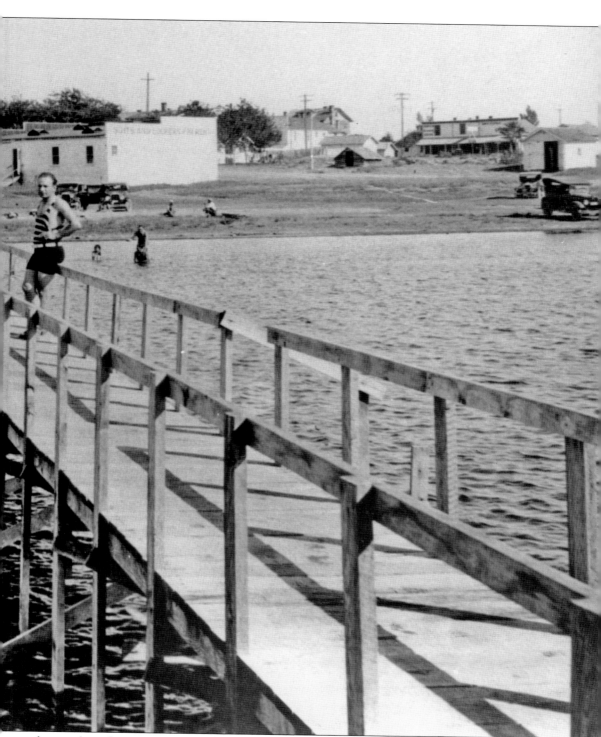

the wooden pilings was great fun. (Courtesy of Duane Nycz.)

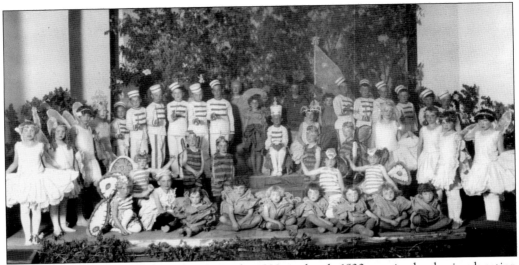

Students attending school in Soap Lake in the 1920s and early 1930s received a classic education and were taught Latin and European literature in the early grades. Gregor Agranoff, a well-known concert violinist, taught music. Beloved teachers Georgia Cuddeback and Amy Dick orchestrated elaborate pageants each year. All students were included in the performances. (Courtesy of Betty Coberly.)

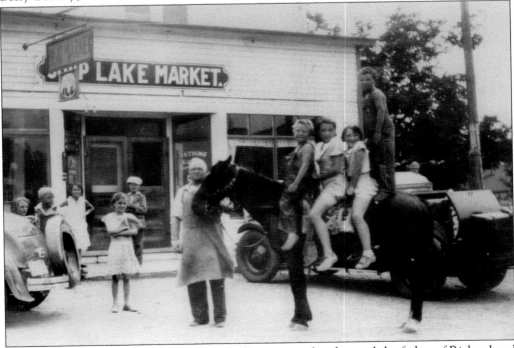

Case Bonthius, standing next to Barney the horse, was a butcher and the father of Richard and Joyce. Richard is standing on the back of Barney. Case owned the Soap Lake Meat Market, a favorite place for children who grew up going to his store, where they would find 50-gallon barrels of pickles, peanut butter, and sauerkraut sold by the pound along with taffy, pop, and other untold delights. (Courtesy of Joyce Pinkerton.)

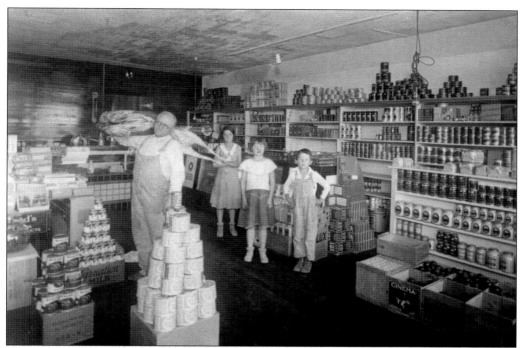

This photograph is of Case Bonthius, the butcher, with his children Joyce in the middle and Richard on the right. Case also supplied ice to the town. (Courtesy of Joyce Pinkerton.)

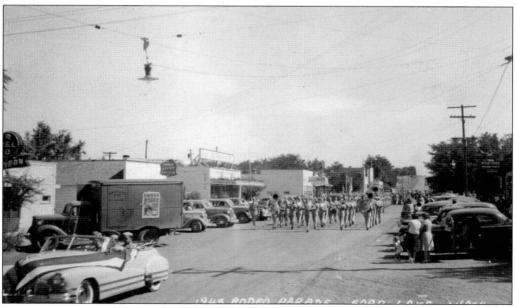

Not a year went by without a parade in Soap Lake, usually held around the Fourth of July. In this image, the band is heading west on Main Street in front of what is today the Masquers Theater. The first Suds 'N Sun Festival was held in 1954 to celebrate the city's purchase of the west beach. (Courtesy of Duane Nycz.)

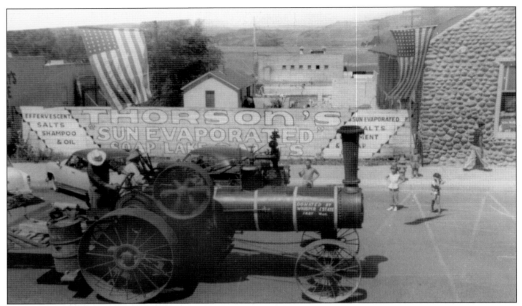

This photograph was taken from an upstairs apartment, making it possible to see across the fence at Thorson's Hotel and Soap Lake Products Company toward the salt manufacturing facility in the background. Between the fence and the steam plant are two reservoirs containing Soap Lake water evaporating in the sun.

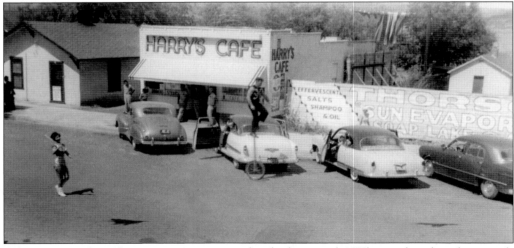

What is a parade without someone on a six-foot-high unicycle? What makes this photograph priceless is that it is taken in front of Harry's Café, one of the favorite places to eat and work for many of the people who grew up in Soap Lake in the 1930s and 1940s.

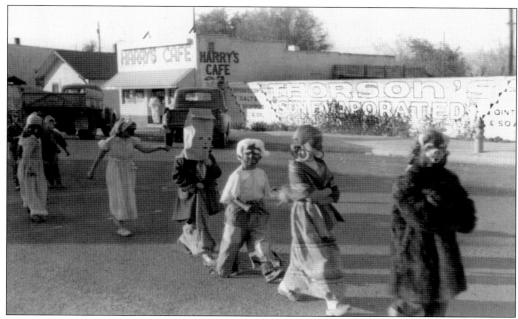

This image is likely of the Halloween parade with children in costume as they walk in front of Harry's Café. Main Street in Soap Lake has been the site of many parades over the years and today hosts soapbox derby races.

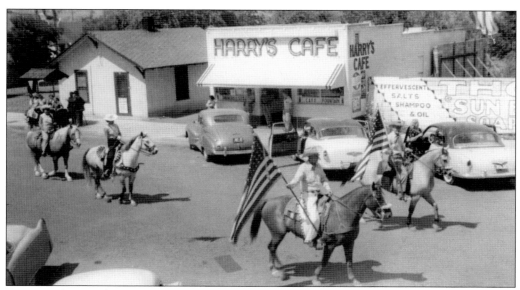

Farmers, along with a population of cattle ranchers, live near Soap Lake. There has never been a parade in town that did not have a horse and rider. The drinking fountain seen along Main Street to the left of Harry's Café is today located in that same spot and serves as an orientation point to buildings that have disappeared with the passage of time.

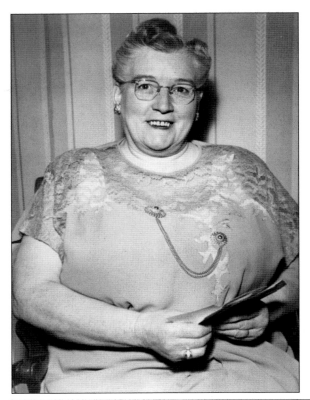

Maggie Waltho, possibly the first female mayor in the country, was a force to be reckoned with. Along with her husband and children, she operated the Waltho Hotel. She was known for her generosity to others as well as her tough approach to city affairs. She defended the rights of nude bathers who had practiced their unclothed sun worship on the west beach for decades. She stood up to the county sheriff defending their right to continue bathing in the nude without restraint. As a compromise with the county sheriff, Mr. Petridge posted rules for the nude bathers.

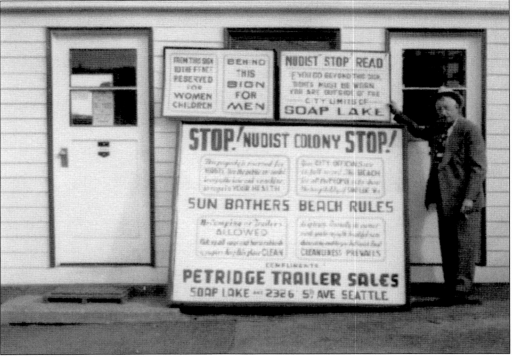

GRANDE & CO., INC.

INVESTMENT SECURITIES
HOGE BUILDING
SEATTLE, WASHINGTON
TELEPHONE MAin 6832

HARRY S. GRANDE
PRESIDENT

August 15, 1947

Honorable Maggie Waltho, Mayor
Soap Lake, Washington

Honorable Madam:

It has been called to my attention that in recent news releases
emanating from Soap Lake, Washington that certain lovers of
nature have been holding forth on the west shore of Soap Lake.
In view of the fact that I am the owner of ten acres of water-
front property comprising the west shore of that lake, I wanted
to advise you that if they derive pleasure from enjoying the
benefits of nature on my property it is entirely agreeable with
me, and I wish that you would not molest them.

I am directing a similar communication to the Sheriff of Grant
County.

Yours very truly,

H. J. Grande

HSG:PW

On August 22, 1947, the *Soap Lake Reporter* reported the following: "To be or not to be—that is, the nudist beach on the west shore of Soap Lake—which dominated the council meeting for nearly two hours on Wednesday evening after A.C. Petridge asked for a business license to operate the nudist colony. After listening to scores of nudists—who were fully attired then—tales of the benefits derived from the sun and water, the council was in full accord that the colony should continue, providing strict sanitation rules prevailed."

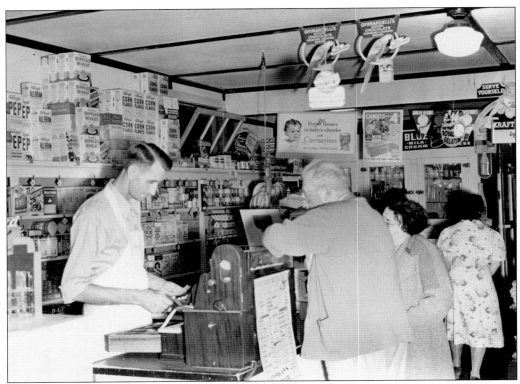

Mike and Evelyn Lannigan came to Soap Lake in 1936. Shortly afterwards, they opened their small grocery store on Main Street. They bought the store from Al Hampton. Mike Lannigan would delivery groceries on his bicycle on his way home each evening from the store. Evelyn became a dedicated and hardworking volunteer in the community. (Both, courtesy of Linda Bonneville.)

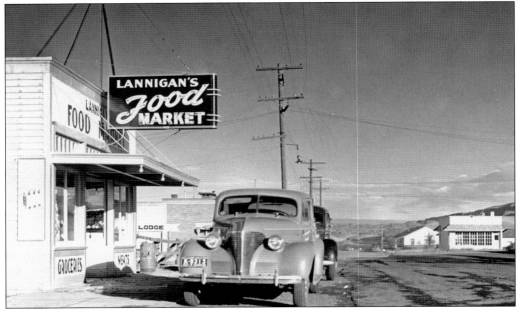

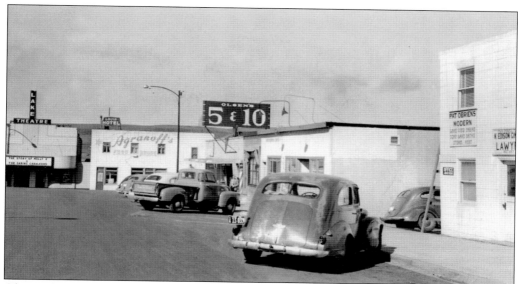

Olsen's 5 & 10 store was very popular and remembered by all who shopped there, including Bernetta Ontiveroz, who noted in the following post on Facebook: "I got a sun dress at that store. It was white and blue stripes. It was too big, but I wore it anyway, loved that dress." (Courtesy of Duane Nycz.)

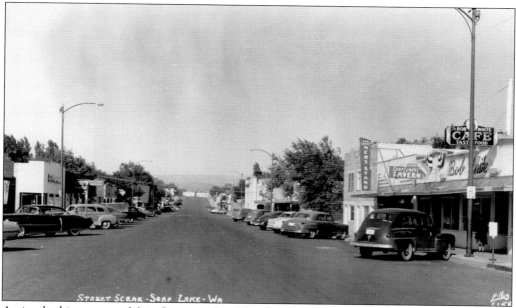

A view looking west up Main Street in the 1950s shows the Bob White Café on the right next to the Sportsmans Tavern and the newsstand. The following is from Dee Carsonon on Facebook: "I spent hundreds of hours in the old Bob White Café in the early 1960s. 'Grannie' was one hell of a woman and a terrific cook. She always served the best French fries covered in brown gravy. I don't know how many hours and dollars I invested playing the dime pinball machines in her restaurant. The food wasn't the only good thing there. I married one of the waitresses. Been together about 45 years now." (Courtesy of Klasen family archives.)

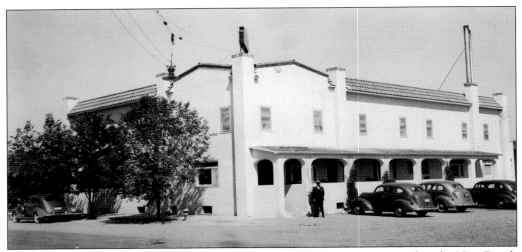

After the Beach Hotel was partially destroyed by fire in 1929, it was reopened as the New Beach Hotel in November 1931. Recognized as "elegant and classy," it remained one of the most popular hotels in Soap Lake until it burned to the ground in 1980. (Courtesy of Marina Romary.)

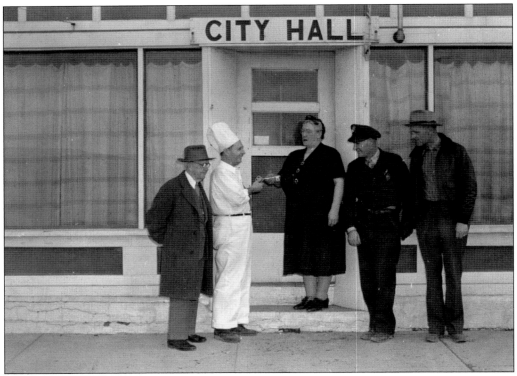

It was said that she was the first woman mayor in the nation. No one knows for sure, but Maggie Waltho, who became mayor of Soap Lake in 1946, made national news when she striped the chief of police of his badge and gun after an altercation at a bar. (Courtesy of George Waltho.)

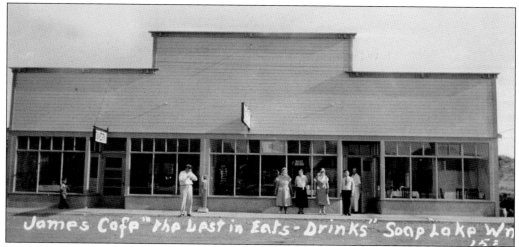

James Cafe "The Best in Eats - Drinks" Soap Lake Wn

Second from the left in this photograph is Joyce Bender. She came to Soap Lake in 1934 in response to an opening for a waitress job at the James Café. She went to work for James "Jimmy" and Myrtle Arvan, who started the café. She later married George Notaras, who owned a bathhouse and several apartments next door to Harry's Café. Joyce spent many years helping George manage the rental units and bathhouse. They raised a family in Soap Lake, and some of their children, grandchildren, and great-grandchildren continue to operate or work in businesses in Soap Lake. (Courtesy of Marina Romary.)

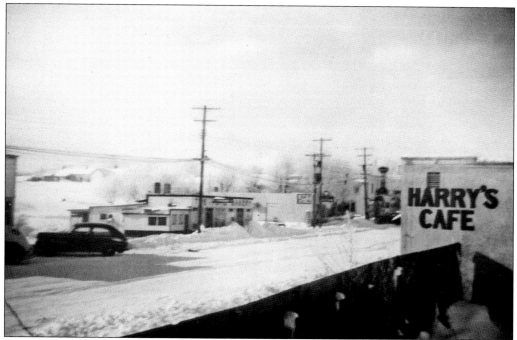

The bakery shown here across the street from Harry's Café is remembered by many for the fresh bread, pies, cakes, and cookies and the exquisite aroma that greeted customers at the door. Note the fence to the left of Harry's Café. It was once a barrier between the sidewalk and Thorson's salt evaporation reservoirs.

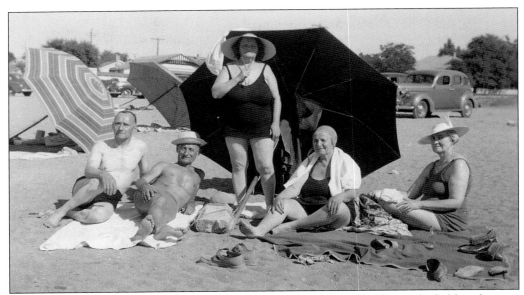

The east and west beaches at Soap Lake have long hosted a relaxed crowd of old and young alike. The beaches are and always have been free. Mud is collected from shallow waters near both beaches, and often people are seen lounging in the sand covered from head to toe with black mud. After drying to a dark gray color, they swim into the shallow lakeside to wash it off. (Courtesy of Duane Nycz.)

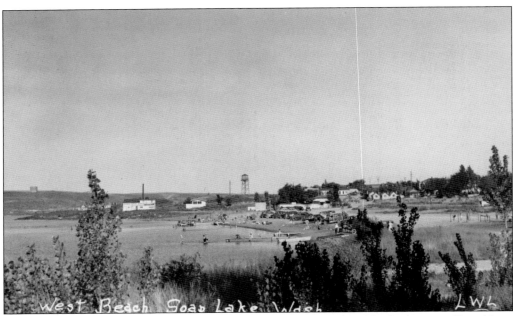

This is a view of the west beach looking eastward. The hulk of the old salt plant is still visible in the middle left side of the photograph, taken in the 1960s. (Courtesy of Duane Nycz.)

CANNY DOG CURES SELF IN SOAP LAKE

this is Shorty an amazing Dog —who was injured in an auto accident.
His leg was amputated. But Shorty picked at the stitches until he had
a badly infected stump. Shorty took to bathing in SOAP LAKE and
today he is a fully recovered 3 legged citizen of SOAP LAKE. Oct., 1952

This is the only postcard in America with the picture of a dog that cured himself. "My father, Harry Druxman had the postcard printed. It was one of the methods he used to help promote Soap Lake as a resort town. The story about the dog is absolutely true," said Michael Druxman. (Courtesy of *Soap Lake Heritage*.)

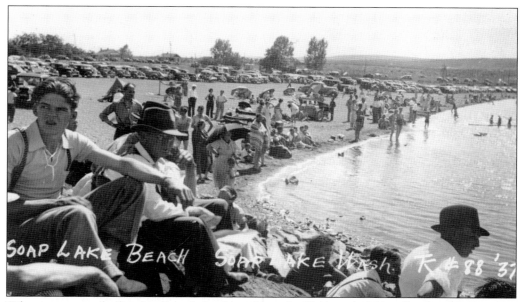

SOAP LAKE BEACH SOAP LAKE Wash. R #88 '37

When someone who lived in Soap Lake throughout the 1940s and 1950s talks about the beaches packed with visitors and shoulder-to-shoulder foot traffic on the streets of Soap Lake, this is what they mean. Soap Lake was and still is a place that people return to year after year, bringing their families and friends. (Courtesy of Duane Nycz.)

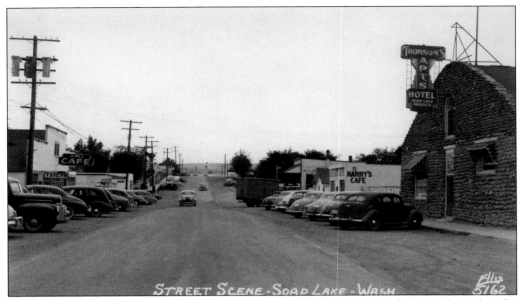

The camera faces the small hill that heads west up Main Street before the turn that takes the traveler south toward the highway. In this classic 1950s photograph, the James Café on the left with its beautiful neon sign looks busy, as does every other business on Main Street from Thorson's Apartments to Harry's Café. (Courtesy of Klasen family archives.)

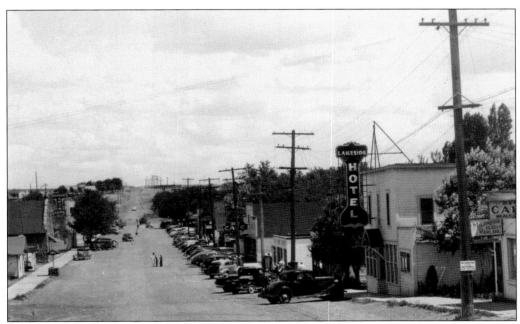

From a position at the top of the same hill noted above is a view east toward what is today called Highway 17; those who remember a time when there was no highway also know it as Daisy Street. (Courtesy of Klasen family archives.)

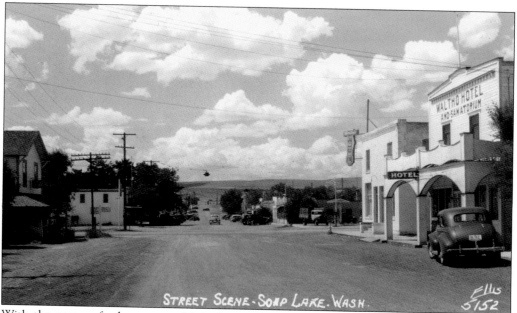

STREET SCENE - SOAP LAKE. WASH.

With the camera farther east on Main Street, this is the view from the Waltho Hotel, which had by the 1950s expanded to include the old brick C.J. Webber Building on the corner of Main Street and the highway. The corner building is now where the Soap Lake Art Museum is located. (Courtesy of George Waltho.)

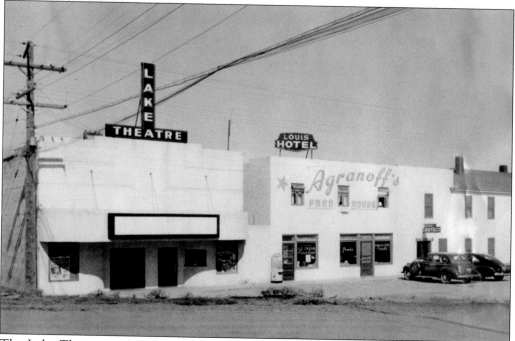

The Lake Theater replaced the Sunset Theater, and the Louis Hotel became Agranoff's, where the Chinese chef Louie Woon surprised everyone with his culinary skills. (Courtesy of Marina Romary.)

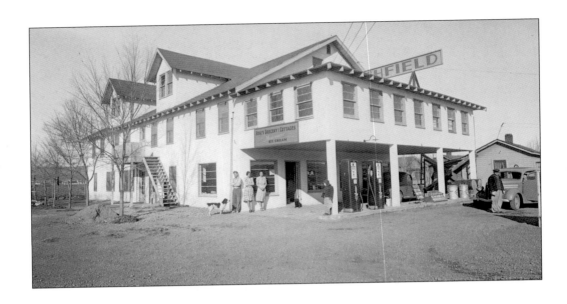

The Rose Apartments, gas station, and store filled an entire corner on Daisy Street in the 1960s. It is remembered not only by many who stayed at the apartments but also by the friendly owners and staff. Later, it was called the Fourth Street Grocery, where penny candy was purchased and pop bottles redeemed for the 3¢ deposit. It was destroyed by fire in the 1960s. (Both, courtesy of Elaine Mullinex.)

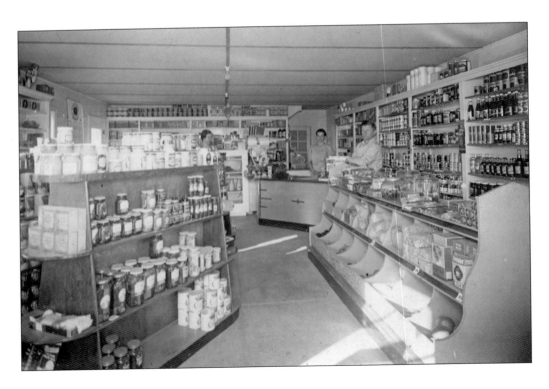

Grand Opening
OF
THE GARDEN
SOAP LAKE'S NEW
AND MODERN
Dance Pavilion
HALLOWEEN
EVE
Saturday, Oct. 30th
Special Attractions
And Favors
DANCE TO THE
DIN GRINKERS Band

A Friendly Place for Friendly People

Located between Karl's Kozy Kitchen and the Oasis building on Main Street, Soap Lake, Wn.

9:30 p. m. Admission 75 Cents

The opening of another dance pavilion in Soap Lake in 1937 marked another opportunity for fun times in a place where people really knew how to kick up their heels. Maybe it was because people came to town not feeling well, and as they got better, all they could do was celebrate. Either way, dance halls in Soap Lake were a fun place to be on a Friday or Saturday night. To this day, there is a dance floor and weekly dancing at the Businessman's Club in the basement of the Notaras Lodge Office.

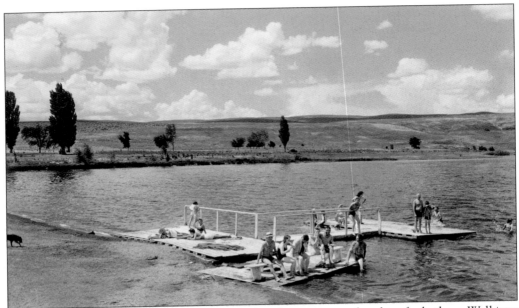

The swimming platforms, located on the west beach, were a popular place for bathers. Well into the 1980s, there was some type of platform near shore. (Courtesy of Duane Nycz.)

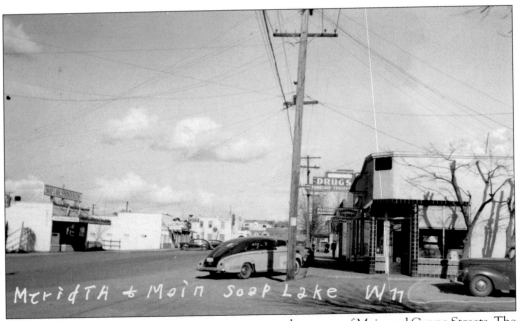

This photograph from the 1950s is a view east across the corner of Main and Canna Streets. The drugstore was once a restaurant, and the bathhouse across the street is the current location of the Healing Water Spa. (Courtesy of Duane Nycz.)

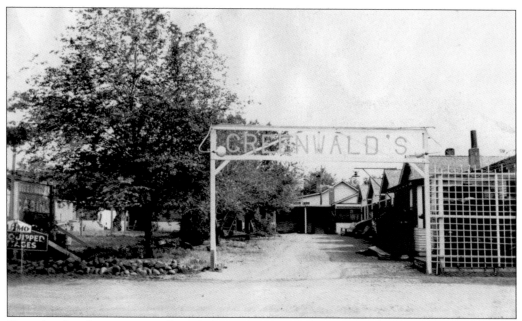

Over the decades, visitors to Soap Lake returned year after year, and many stayed and started businesses. Julius Greenwald was one of these people. In 1922, he was known as the famous "boy wonder" from Seattle who could sing baritone and soprano in a double voice. He was also an exceptional organ player and was a hit wherever he travelled. He started Greenwald's Cabins and Rentals in Soap Lake so that he would have a place to live when he visited. (Courtesy of Linda Bonneville.)

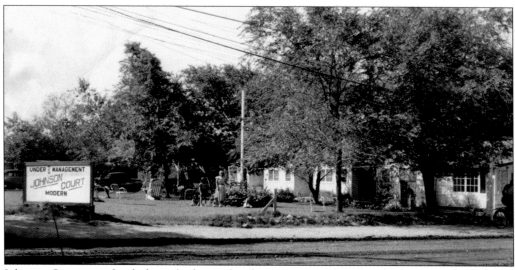

Johnson Court, another lodging facility with cabins, was a popular place for families with children. It was located only a few blocks from the west beach. (Courtesy of Linda Bonneville.)

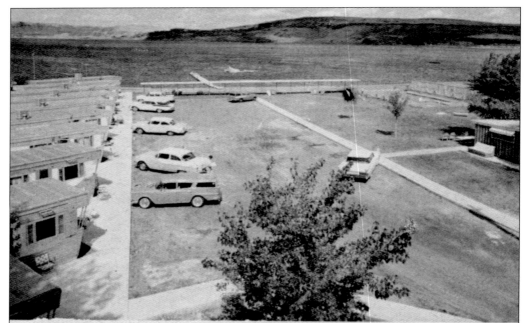

AERIAL VIEW OF TUMWATA LODGE, SOAP LAKE, WASH.

Tumwata Lodge

THE RESORT ON SOAP LAKE

with

Free water skiing and lessons
Private, Sandy Beach — Lawn Games
Heated 20x40 Swimming Pool
Single and Family Units — 100% Mineral Baths
(Available only to Guests of the Lodge)

300 West Main Ave. Ph. CH 6-2931

Faye Bigger built the Tumwata Lodge in 1949. It was a popular family lodging spot. Gov. Albert Rosellini stayed there in 1953. Faye sold the Tumwata in the mid-1950s, and the new owner added a swimming pool, trailer hook-ups, and a dock, as seen in the photograph.

Ten

SUDS 'N SUN

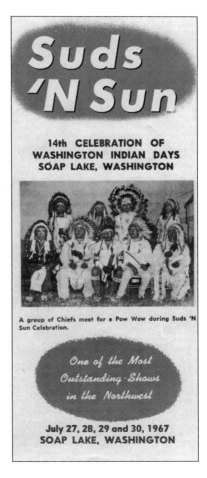

Suds 'N Sun

14th CELEBRATION OF
WASHINGTON INDIAN DAYS
SOAP LAKE, WASHINGTON

A group of Chiefs meet for a Pow Wow during Suds 'N
Sun Celebration.

*One of the Most
Outstanding Shows
in the Northwest*

July 27, 28, 29 and 30, 1967
SOAP LAKE, WASHINGTON

The Indian encampment began with the inauguration of the Suds 'N Sun Festival in 1954 in recognition of the relationship of the town with the native people. From the time it started and through the 1960s, it was the largest Indian encampment held in the Northwest. There were sometimes over 100 teepees each year.

These little girls were performing the "Canoe Dance" when their picture was taken during 1967 Suds 'N Sun Celebration.

● ● ●

SCHEDULE

Thursday, July 25, 8:30 P. M. — Pro Wrestling in the Camas Bowl, East Beach, Harry Elliott, promotor

10:00 P. M. to 1:00 A. M. — Street Dance

Friday, July 26, 5 to 7:30 P. M. — Salmon feast, East Beach

8:00 P. M. — Opening ceremony, ceremonial Dancing, and Indian Beauty Contest in the Camas Bowl

Saturday, July 27, 10:00 A. M. — Grand Parade

5:00 P. M. to 7:30 P. M. — Western Style Barbecue at East Beach kitchen

8:00 P. M. — Ceremonial and Competition Dancing and Teepee Raising Contest in Camas Bowl

Sunday, July 28, 6:00 to 10:00 A. M. — Cowboy breakfast at East Beach kitchen

8:00 P. M. — Finals in Competitive War Dancing in Camas Bowl

EVERGREEN SHOWS will provide many rides and special attractions — Fun for all — All four days

● ● ●

SUDS 'N SUN OFFICIALS

Bill Wagner, President

Ray Southworth, Vice-pres. Bill Champion, Director
Francis Asker, Secretary Chris Bakken, Director
Rod Powell, Treasurer J. Cain, Director
Iva Stevenson and Sam Woody, Advisers

For Further Information contact:
Bill Wagner, Box 861, or Francis Asker, Box 66
Soap Lake, Washington
SUDS 'N SUN, INC., SOAP LAKE, WASH. 98851

SEE YOU AT THE CAMAS BOWL

Native Americans performed ceremonial and competition dancing, and there were stick games and a salmon feast. Also held in the Camas Bowl was an Indian beauty contest. Soap Lake citizens would also select a princess, and the Indian princess and the princess selected by the town would dance together during an opening ceremony.

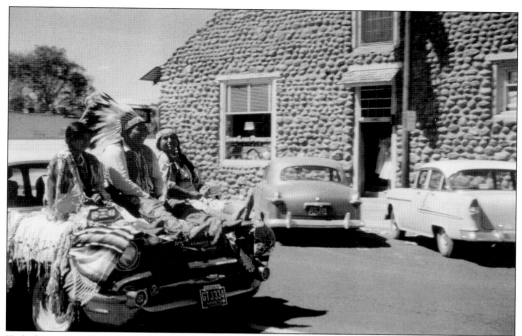

Tribal members from Oregon, Idaho, Washington, and Montana participated in the Suds 'N Sun Festival in Soap Lake wearing full regalia and enjoying the happy times over the weekend of cultural sharing and competition. The festivities began on Saturday morning with the parade.

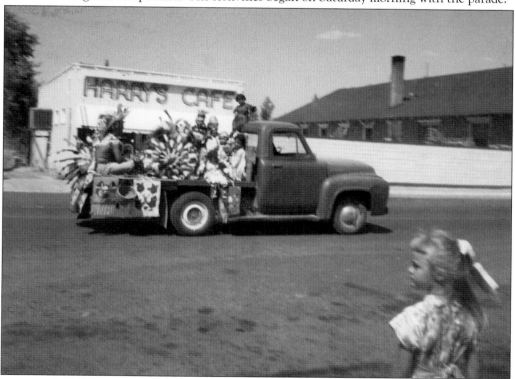

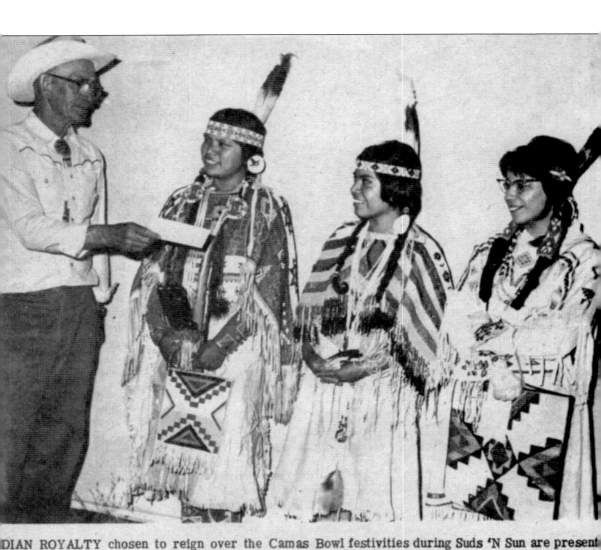

DIAN ROYALTY chosen to reign over the Camas Bowl festivities during Suds 'N Sun are present th checks by Suds 'N Sun President Sam Woody. Girls from left are, Queen Marlene Hunt, 16, Whi an; Princess Connie Villalovos, 16, Nespelem and Princess Verna Bad Eagle of Brocket, Albert

On July 31, 1961, the *Grant County Journal* reported the following: "Sam Woody, President of Suds 'N Sun, Inc., said that it had been the most successful celebration in its history. Sunday night 196 costumed dancers took part from tribes throughout the Northwest. This was a record number for the Camas Bowl. Attendance for the two nights was estimated between 2,000 and 2,500."